248

Marc

Chagall

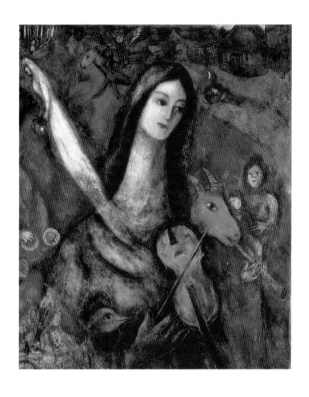

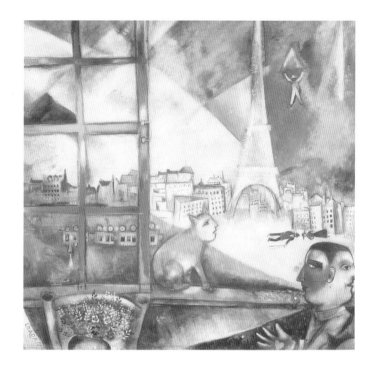

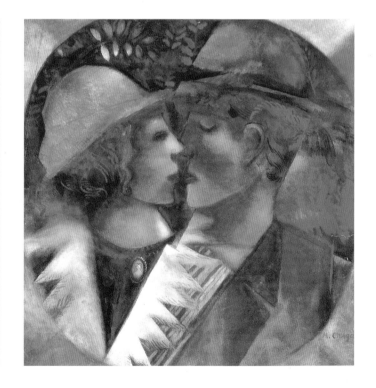

© 2005 Confidential Concepts, worldwide, USA
© 2005 Sirrocco, London, (English version)
© 2005 Chagall Estate / Artists Rights Society, New York

Published in 2005 by Grange Books
an imprint of Grange Books Plc
The Grange Kingsnorth Industrial Estate
Hoo, nr Rochester Kent ME3 9ND
www.Grangebooks.co.uk

ISBN 1-84013-584-0

Printed in China

Marc

Chagall

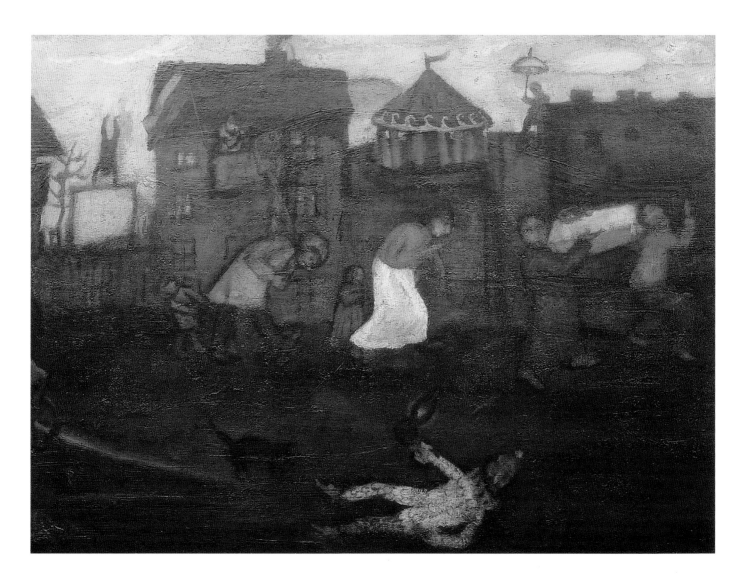

1. **Kermis** (Village fair)
 (1908), Oil on canvas,
 68 x 95 cm, Collection
 Wright, Judington,
 Santa Barbara,
 California.

THE EARLY PERIOD

Marc Chagall was born into a strict Jewish family for whom the ban on representations of the human figure had the weight of dogma. If one is unaware of the nature of traditional Jewish education one can hardly imagine the transgressive force, the fever of being which propelled the young Chagall when he flung himself on the journal *Niva* (Field) to copy from it a portrait of the composer Rubinstein. This education was based on the historic law of Divine Election and covered the religious side of life only. The transmission to the very core of the Jewish hearth was essentially effected through oral means. Each Jewish house is a place made holy by the liturgy of the word. The Chagall family belonged to the Hassidic tradition: we should emphasize here that this form of piety - *Hassid* means devout - gives preference to direct contact between the individual and God. The dialogue which is thus set up between the faithful and Yahweh exists without the mediation of rabbinical pomp and display. It is born directly from everyday ritual and is expressed in the exercise of personal liberty. Hassidism lies outside the scholarly Talmudic culture, the institutional commentary of the synagogue. It was historically found in rural Russian and Polish communities, communities based on the original fundamental nucleus of Jewish society which is, of course, the family.

Chagall's father, Zakhar, was a pickler at a herring merchant's. Sensitive, secretive, taciturn, the figure of Zakhar seems to have had the tragic dimension inherent in the destiny of the Jewish people. «Everything in my father seemed to me to be enigma and sadness. An inaccessible image», Chagall wrote in *My Life*. On the other hand, his mother, Feyga-Ita, the eldest daughter of a butcher from Liozno, radiated vital energy. The psychological antithesis of their characters can be seen in Chagall's very first sketches and in his series of etchings produced for Paul Cassirer in Berlin in 1923 which were intended to illustrate *My Life*. This antithesis, so strongly felt by Chagall, embodies the age-old experience of the whole of Jewish existence: his father and mother, in the artist's paintings, in the very heart of the plastic space of the picture or drawing, bring into play not only the specific reality of a memory but also the two contradictory aspects which form Jewish genius and its history - resignation to fate in the acceptance of the will of God, and creative energy bearing hope, in the unshakeable sense of Divine Election.

Marc had one brother and seven sisters: David, of whom he produced some moving portraits but who died in the flower of youth; Anna (Aniuta), Zina, the twins Lisa and Mania, Rosa, Marussia and Rachel, who also died young. If family life was difficult, it was not miserable. It was part of the life of the stedtl, that specifically Jewish cultural reality connected to the social structure of the ghetto. In Vitebsk this reality fitted into the structure of rural Russian life.

In the late nineteenth century Vitebsk was still a small town in Byelorussia, situated at the confluence of two waterways, the Dvina and the Vitba. Its economy was expanding greatly, but despite the arrival of the railway, the station, small industries and the river port, the town still retained the characteristics of a large rural village. While the numerous churches and the Orthodox cathedral gave it a more urban appearance, most of the houses were still of wood and the streets, frozen in winter, running with water in spring, were not yet paved. Each house, evidence of an economic unity founded on a traditional domestic way of life, had its little garden and poultry-yard. With their wooden fences and multi-coloured decoration the houses of Vitebsk live on eternally in Chagall's pictures.

It was from this childhood experience that the pictorial schemes of Chagall's plastic vocabulary originate. But the fragments of memory, which we easily identify in concrete objects even in the very first works - the room, the clock, the lamp, the samovar, the sabbath table, the village street, the house of his birth and its roof, Vitebsk recognizable through the domes of its cathedral - did not crystallize into clearly defined images until after the passage of many years. It was only in obeying his calling «Mummy... I would like to be a painter¹», that is to say in tearing himself away from his family and social milieu, that Chagall could evolve his own pictorial language.

Chagall succeeded in persuading his mother to enrol him in the school of drawing and painting of the artist Pen. But the methods of training and the laborious copying exercises soon ceased to satisfy the young Chagall. That which he was still seeking confusedly, that which he barely touched upon in his first daring colouristic experiments, had nothing in common with the academic tradition to which Pen adhered. The painting which Chagall was carrying within himself was poles apart from that representative realism which Pen inherited from the Wanderers. Rebelling against all teaching, from 1907 Chagall began to show a precocious capacity for invention - did he not use the colour violet in a way which defied all known laws? - the autodidactic quality which is the mark of true creative spirits. The painter's destiny worked itself out in the image of some hero of the great fundamental myths which make up the collective subconscious.

2. *Self-Portrait* (1909), Oil on canvas, 57 x 48 cm, Kunstsammlung Nordrhein-Westfalen, Düsseldorf.

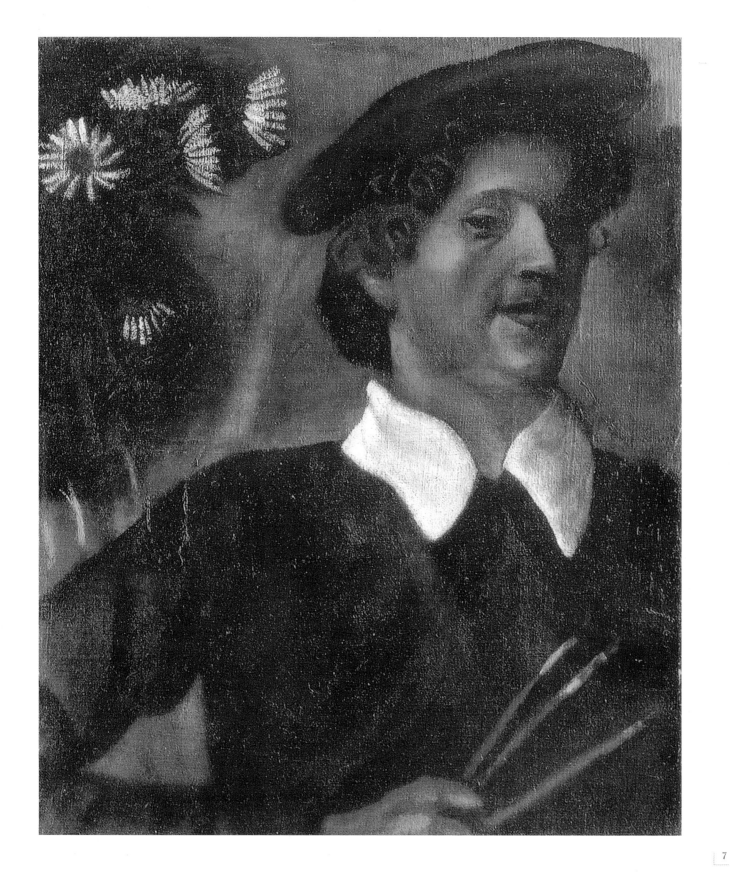

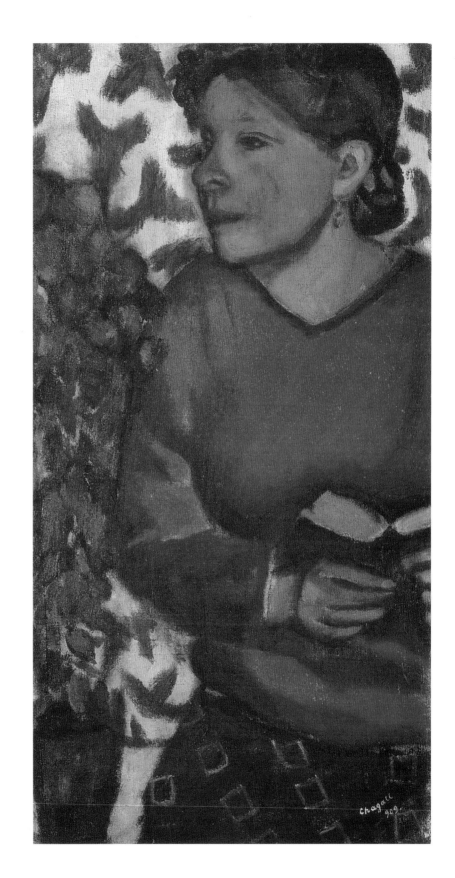

3. **The Artist's Sister**
(Mania) (1909), Oil on
canvas, 93 x 48 cm,
Wallraf-Richartz
Museum, Cologne.

4. **My Fiancée in Black
Gloves** (1909), Oil on
canvas, 88 x 65 cm,
Kunstmuseum, Basle.

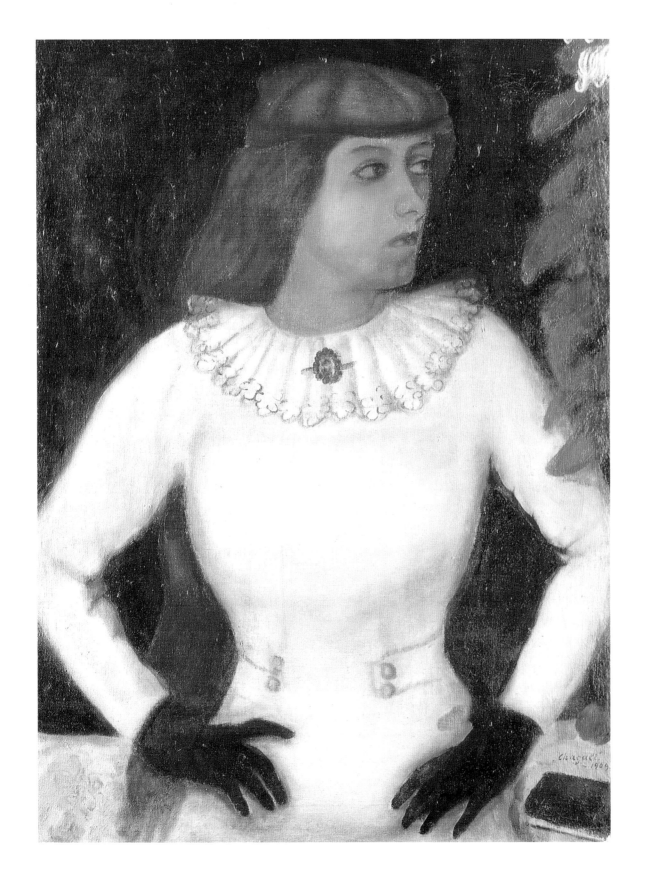

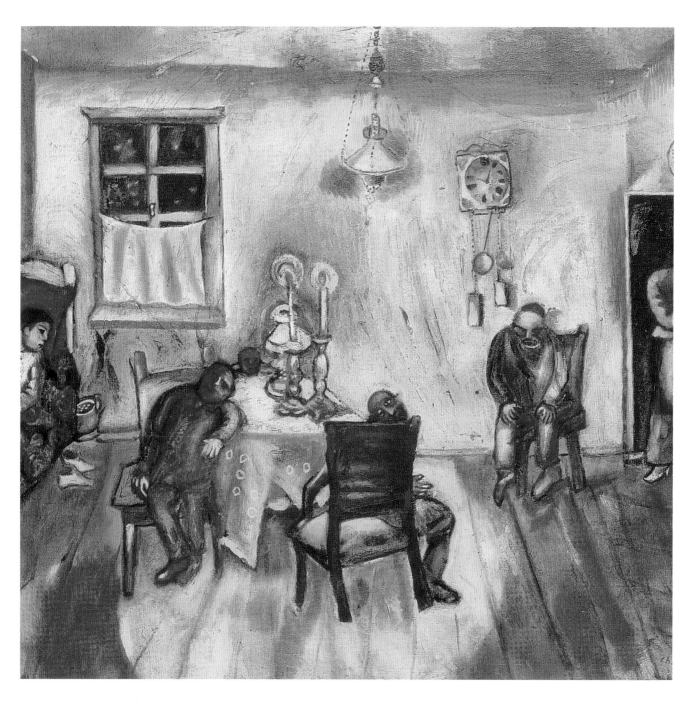

5. **Sabbath** (1910),
 Oil on canvas,
 90 x 98 cm, Wallraf-
 Richartz Museum,
 Cologne.

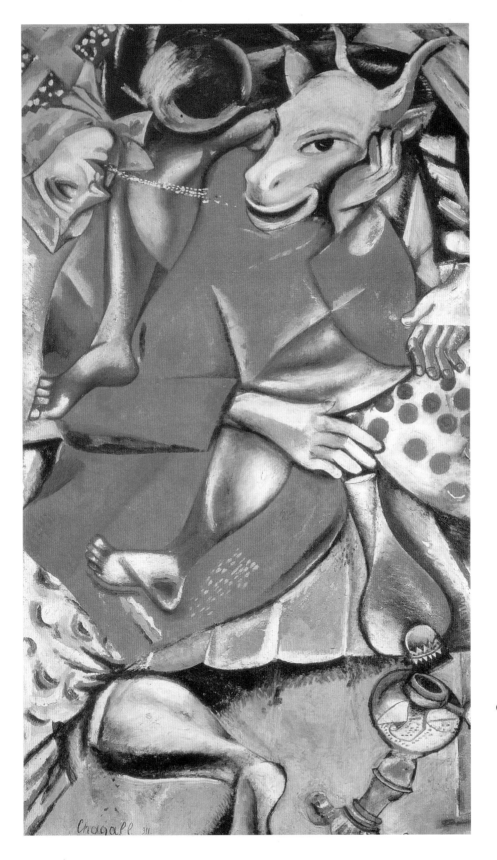

6. *Dedidcated to my Fiancée* (1911),
Oil on canvas,
196 x 114.5 cm.
Kunstmuseum, Bern.

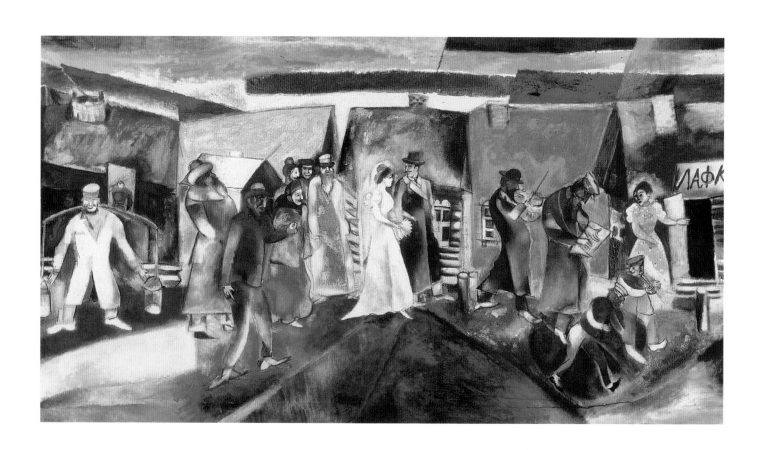

7. ***The Wedding*** (1910),
 Oil on canvas,
 98 x 188 cm,
 Collection the artist's
 family, France.

It was a destiny shaped through trials, of which the most decisive was tearing himself away from the place of his birth. In 1907, accompanied by his friend Viktor Mekler, Chagall left Vitebsk - one of the main symbolic images in his later work for St. Petersburg.

His departure for St. Petersburg gives rise to several questions. Chagall could in fact have wished to pursue his artistic quest, which was only just beginning, in Moscow. The choice of St. Petersburg is of particular significance.

Chagall was conforming above all - without being aware of it - to a tradition stemming from the Renaissance, a tradition which makes travel one of the principal means of any apprenticeship. Whilst painting is also a craft - despite the romantic revolts, the status of the artist at the dawn of the twentieth century was still not that far from the craftsman's status it had in the fifteenth century - the social recognition of this status was inevitably dependent on academic training. St. Petersburg, among other things, was the intellectual and artistic centre of imperial Russia. Much more than continental Moscow, it was a city whose own history was always characterized by an openness towards Western Europe. Through its architecture, its urbanity, its schools and salons, it dispensed a formal and spiritual nourishment which was to enrich the young provincial. Chagall's keen gaze sought the least reflections of the transparent light of the North on the surface of the city's canals. He came to seek St. Petersburg's excellence. His failure in the entrance examination for the Stieglitz School did not stop him from later joining that founded by the Imperial Society for the Encouragement of the Arts and directed by Nicholas Roerich.

Nicholas Roerich (1874-1947) had taken part in the production of the journal *Mir Iskusstva* (*The World of Art*), founded in 1898 by Alexander Benois and run until 1904 by Serge Diaghilev. The journal and the artists grouped around it played a decisive role in the general aesthetic debate with which Russia was preoccupied during the first decade of the twentieth century. Its emblem, a northern eagle drawn by Bakst, formally synthesized the objectives they pursued: to create a new art, original because it drew on Russian heritage, but open to the influence of the West, capable of thus bringing about, in a country which had never known such a thing in its history, a veritable Renaissance. *The World of Art* preached the doctrine of art for art's sake.

Like *The World of Art*, *The Golden Fleece*, which ceased to appear in 1909, contributed to the artistic life of the period in question. It made known to the wider public individuals as diverse as Benois, Bakst (meeting with whom played an important role in Chagall's life), Roerich, Golovin, Dobuzhinsky, Larionov, Goncharova…

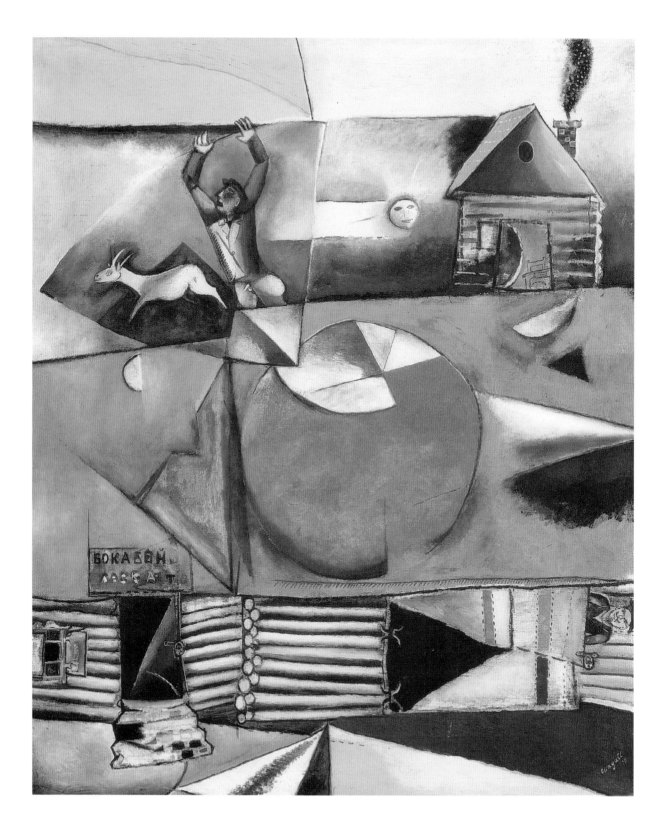

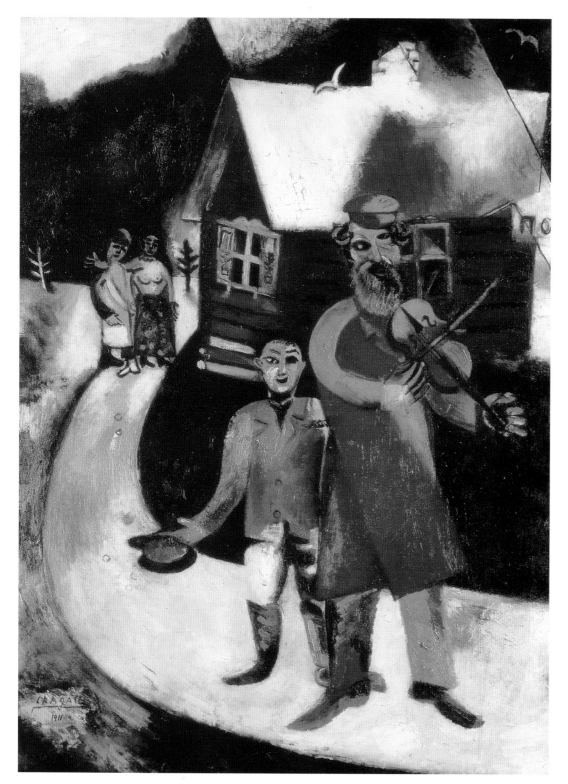

8. ***From the Moon***
 (*The Russian Village*),
 Oil on canvas,
 126 x 104 cm,
 Neue Pinakothek,
 Munich.

9. ***The Violonist*** (1911)
 Oil on canvas,
 94.5 x 69.5 cm,
 Kunstsammlung
 Nordrhein-Westfalen,
 Düsseldorf.

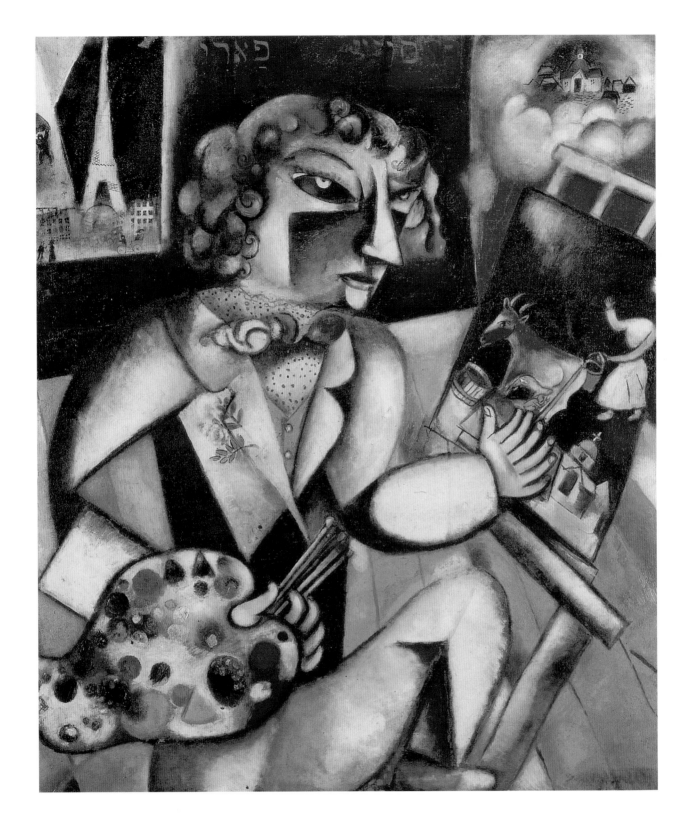

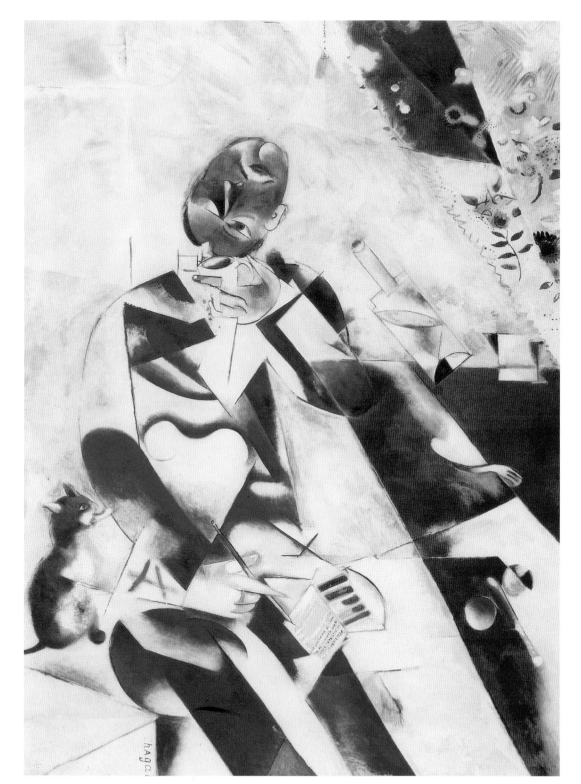

10. *Self-Portrait with Seven Fingers* (1911), Oil on canvas, 128 x 107 cm, Royal Collection, The Hague.

11. *The Poet* (Half past three) (1911), Oil on canvas, 197 x 146 cm, Philadelphia Museum of Art, USA.

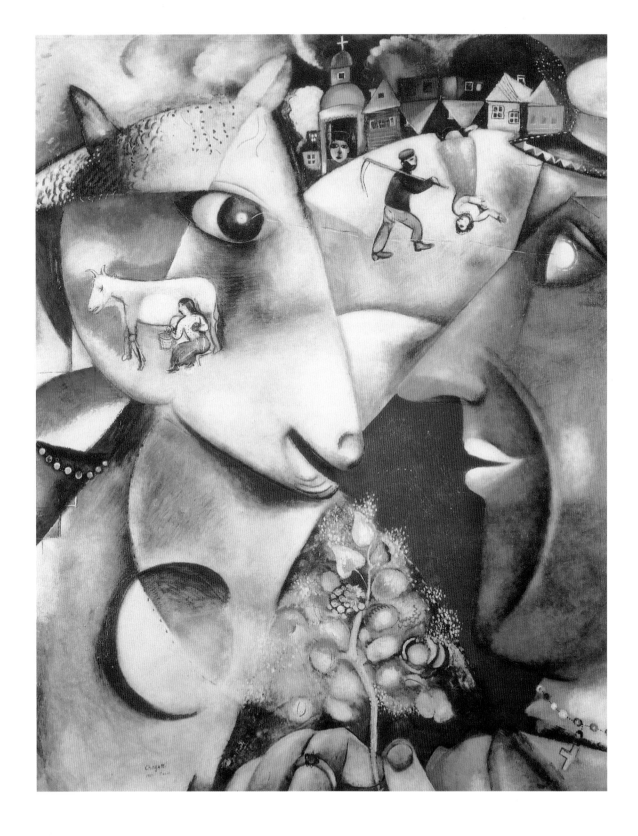

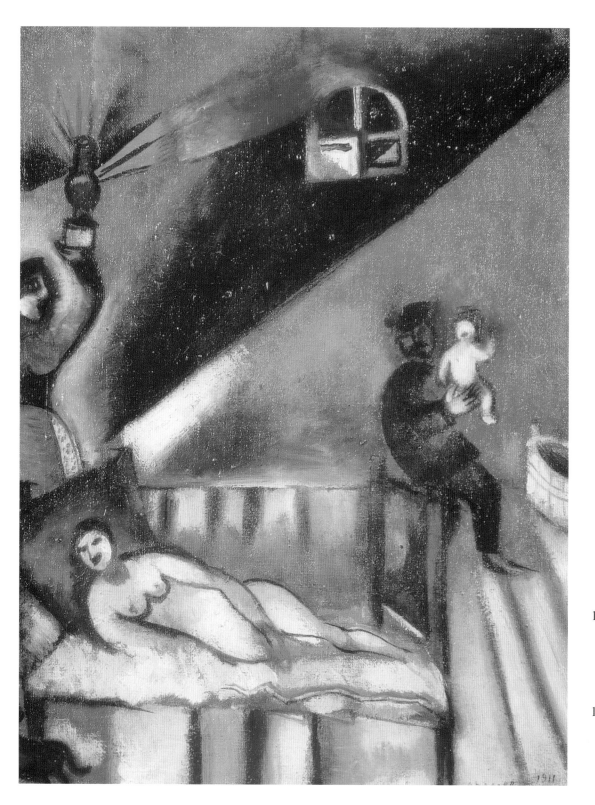

12. *I and the Village*
(1911), Oil on canvas,
191.8 x 150.5 cm,
Museum of Modern
Art, New York.

13. *Birth of a Child*
(1911), Oil on canvas,
65 x 89.5 cm,
Collection the artist's
family, France.

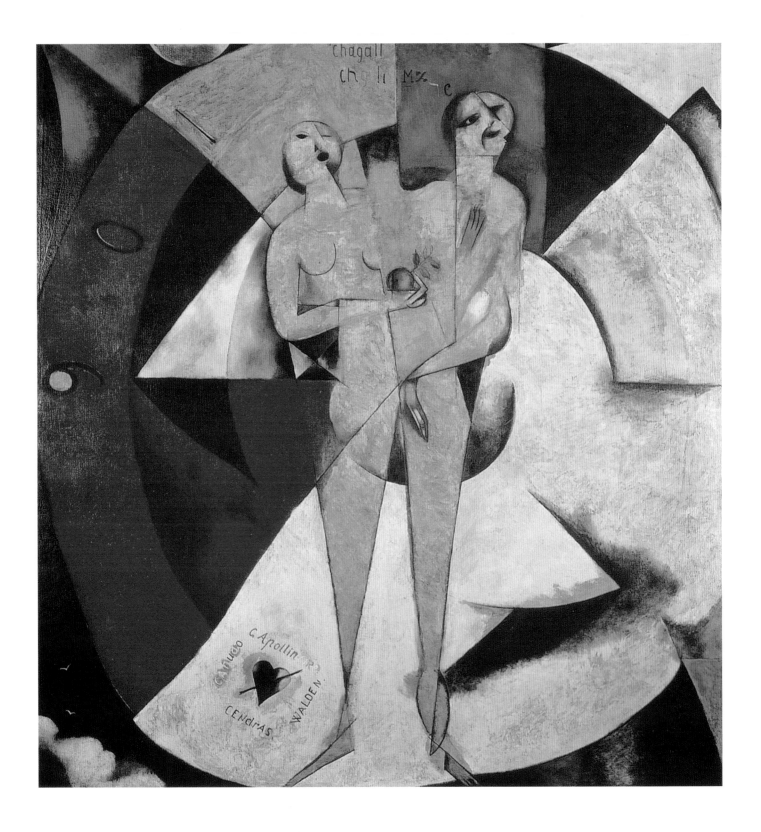

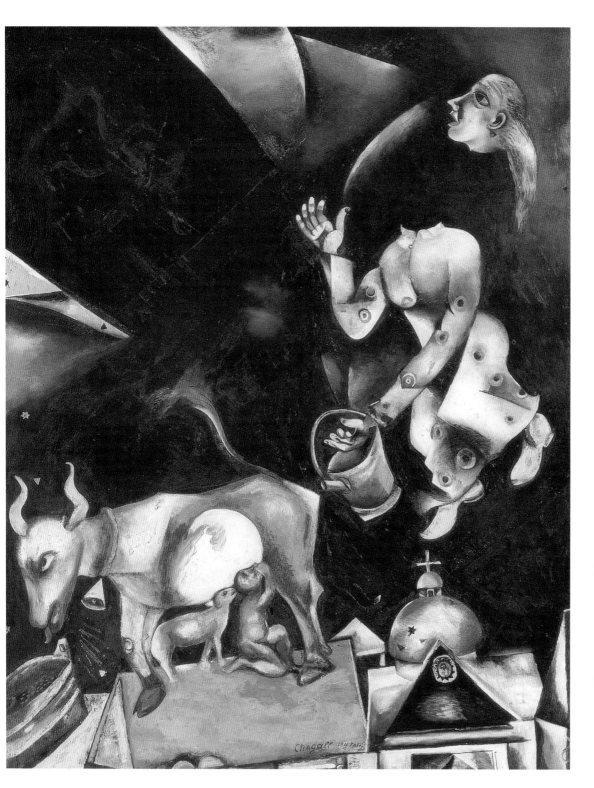

14. ***Hommage à
Apollinaire*** (1912-
1912), Oil on canvas,
109 x 198 cm,
Stedelijk Museum,
Amsterdam.

15. ***To Russia, Asses and
Others*** (1911-1912),
Oil on canvas,
156 x 122 cm, Musée
National d'Art
Moderne, Paris.

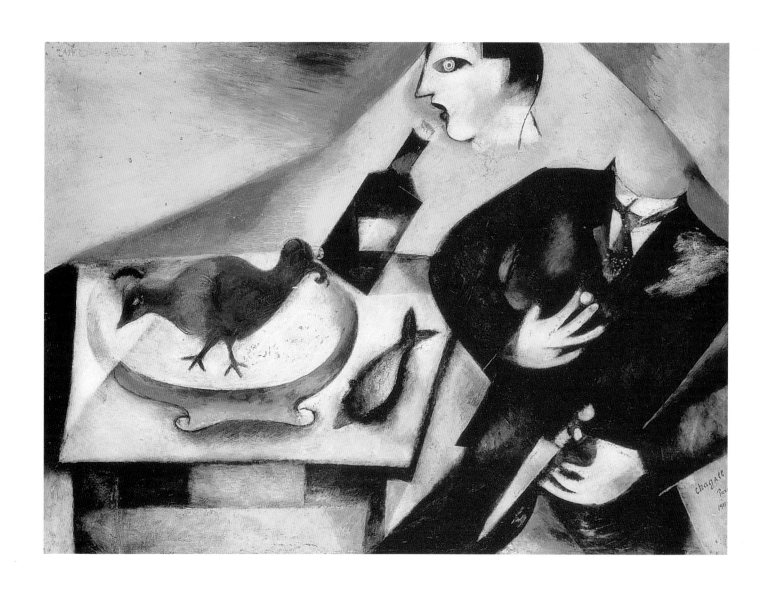

16. *The Drunk* (The
 Drinker) (1911-1912),
 Oil on canvas,
 85 x 115 cm, Private
 Collection.

The Golden Fleece called on Russian artists to create works contemporary in spirit, and as a consequence contributed to the reflection on the idea of modernity which we know was decisive for the evolution of art.

There is no doubt that in St. Petersburg Chagall became aware of the reverberations of the many controversies which were stirring in the realm of painting. However, the teaching of Roerich, little different from that offered by Pen, disappointed him, and the study exercise of copying seemed to him to be a waste of time. «Two years lost in this school», he wrote with bitterness. Two years which allowed him, however, to meet his first patron and collector, the lawyer Goldberg, whose *Drawing Room* and *Study* (1908) he depicted, and above all his future protector, the influential deputy in the Duma, Maxim Vinaver. Chagall frequented the intellectual Jewish circles which revolved around Vinaver and which aimed to revive, with the writer Pozner, the critic Sirkin, and Leopold Sev, Vinaver's brother-in-law, the Jewish journal *Voskhod* (*Renewal*), published in Russian. The participation of the Jewish intelligentsia in the major artistic debate of the time is incontestable. The growing awareness of a specific Jewish cultural identity did not for all that exclude - rather the opposite - the desire to give it a new dimension of national and international universality. *Voskhod* was the instrument of this action. Vinaver and Sev were to open the doors of the famous Zvantseva school for Chagall. This private school had been founded by a rich woman, herself a painter, Yelizaveta Nikolayevna Zvantseva, who, after a stay in Paris, decided to develop a new kind of teaching capable of giving young Russian artists the technical means to develop a totally contemporary form of expression, which they lacked. In St. Petersburg Zvantseva summoned those who were considered to be the greatest artists of the time, Mstislav Dobuzhinsky and, above all, Léon (Lev) Bakst. Bakst had acquired international renown in particular through his collaboration with Diaghilev. An elegant portraitist, he also worked in the sphere of the decorative arts, illustrated books, and above all created brilliant costume and set designs for the theatre and the ballet.

Thus he worked for Diaghilev and his stars, Fokine, Pavlova, Karsavina and Nijinsky. His reputation was outstanding. Chagall knew this and was profoundly impressed by it, even though Bakst, this European, was, like him, Chagall, a Jew. For Chagall, to enter the Zvantseva school, to approach Bakst, was a mark of privilege. Here, close to one of his own, he prepared himself to find that other reality which he was pursuing, which he carried within him, and which he sought to objectivize solely by means of painting. In the freedom of the teaching dispensed by Bakst, bit by bit Chagall elaborated his language, achieved the spatial mastery of colour, and gradually found his style.

He was not influenced by Bakst's Symbolist aesthetic, his decorative mannerism. On the other hand he rapidly mastered one of the painter's demands, which was «the art of juxtaposing contrasting colours whilst balancing their reciprocal influence...[2]»

This can be seen in *The Small Parlour*, dated 1908, executed at the beginning of his period of study with Bakst. On a freely painted delicate rose-coloured background the arabesques of objects - chairs, table, and flower vase - are drawn in brown. The light forms seem to dance within an airy space which is devoid of any illusion of perspective. Depth, without being described, is suggested by the use of a light green which hollows out the ground. In the foreground the double curvature of the back of a chair and the broken angle of a table seem to set the whole space in motion in the manner of certain pastels by Degas. In this work Chagall has also revealed his colouristic skill. The virtuoso audacity of the composition manifests an ease which holds undivided sway in this picture, executed at Liozno, during a visit to the artist's grandfather. Chagall in fact often visited his relatives; he painted his brother and sisters, his parents, and everyday scenes in the desire to sharpen his vision, to make it more refined. He painted Vitebsk, its streets and its wooden houses; Vitebsk, his childhood town and later an emblematic symbol of the land of his birth.

In the autumn of 1909 through Thea Brachman, a friend who had once posed for him, Chagall met his future wife, Bella Rosenfeld. An unforgettable meeting, related by both in their memoirs: «Suddenly I realized that it was not with Thea that I should be but with her! Her silence is mine. Her eyes, mine; it was as if she had known me for a long time, as if she knew my whole childhood, my present, my future; as if she were watching over me, looking closer into me, although I saw her for the first time. I felt that this was my wife [3]», relates Chagall in *My Life*. And in *Lumières allumées*, Bella replies: «I dare not lift my eyes and meet the boy's look. His eyes are now grayish green, sky and water. Is it in these eyes or in a river that I am swimming[4]...»

My Fiancée in Black Gloves (1909) is evidence of the confusion they felt. The work was the first in a long series of portraits of Bella and belongs with his family portraits, of David, of Mania, of Aniuta, but yet it is distinguished from them by its air of grave solemnity. *My Fiancée in Black Gloves* and later *Bella with a White Collar* (1917) are true portraits in their acute observation of the physical and psychological verity of the sitter. But the sitter is not the prisoner of her own individuality. The image of the beloved woman, the image of the love which she arouses, Bella takes on the universal dimension of a type. The picture is in this sense an icon.

17. *Golgotha* (1912),
Oil on canvas,
174 x 191.1 cm,
Museum of Modern
Art, New York.

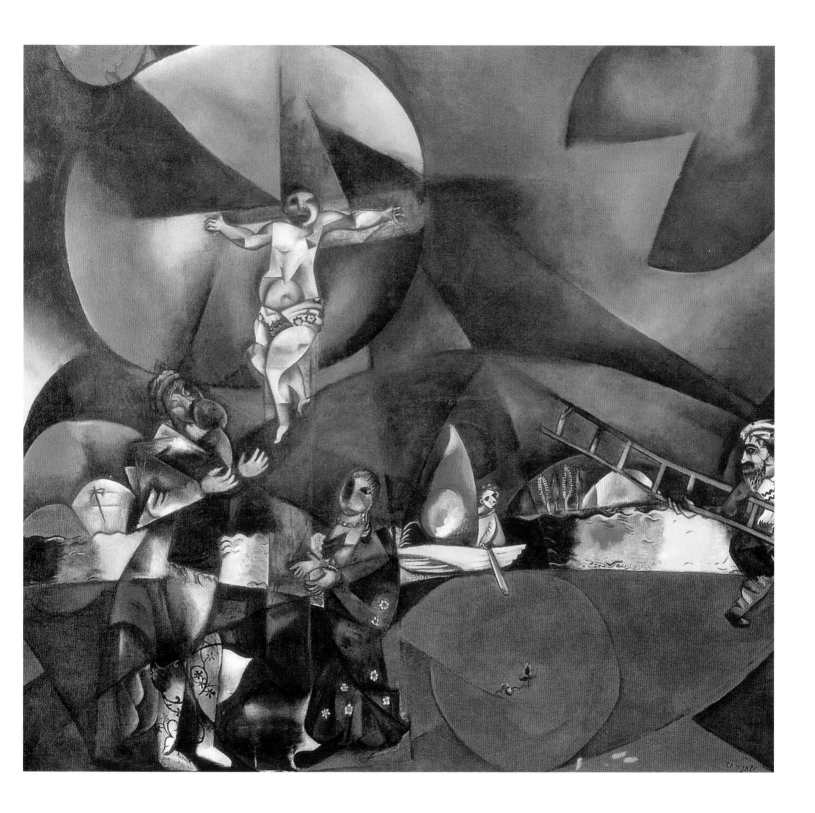

Its function is not representative but demonstrative. It has hidden meaning.

From 1909, Chagall was concerned with the major question of creativity - that of the very status of painting - which practice forced upon him. A means of representing the visible, was painting only the illusionist replication of the material world? Should it not on the contrary be the privileged mode of exploring beyond the appearances which make up perceptible reality? Should it not be, like poetry, one of the means of revealing being? In *The Self-portrait* (1909) the attentive viewer will find more than a few traits of Marc Chagall's eventual artistic system, which was at that very time taking shape. Here we see the volatility of figures, seemingly ready to become weightless and fly through the air, and the exultant, sluggish play of blue Chagallian hues - intense in the clothes, dissolving in the sky (is it not from here that this sense of weightlessness, of soaring, derives?) and melting in the infinitely sad and slightly playful eyes; here we see the painful sadness of the serene smile, the golden-pink brushstrokes in the background, and the suppressed sense of celebration which there always is in life, if you are only able to find it.

The historical circumstances surrounding Chagall's departure for Paris are now well known. The lawyer Vinaver, his protector and first patron, gave him a grant in exchange for a canvas, *The Wedding* (1910), and a drawing. The grant, 125 francs, had to enable the young man to stay abroad for four years. A man who espoused a humanist culture, Vinaver hoped that Chagall would leave for Rome, but he opted instead for Paris. The artistic radiance of the French capital was indisputable, and Chagall was not mistaken: Paris was to be his «second Vitebsk». At first isolated in the little room on the Impasse du Maine, at La Ruche Chagall soon found numerous compatriots also attracted by the prestige of Paris: Lipchitz, Zadkine, Archipenko and Soutine, who were to maintain the smell of his native land around the young painter. From his very arrival Chagall wanted to «discover everything». And to his dazzled eyes painting did indeed reveal itself. First of all, painting in the museums. In the Louvre he discovered Chardin, Fouquet, Rembrandt: «It was as if the gods were standing before me.[5]»

Painting of which he had dreamed in Vitebsk or St. Petersburg, the painting of eternity, where the eternity of painting could be read. Then the art which was closer to Chagall, that of Courbet, Manet, Monet, the first revolutionaries in the way of looking. The whole historical dimension, the whole aesthetic and cultural dimension of the history of painting was unveiled before Chagall.

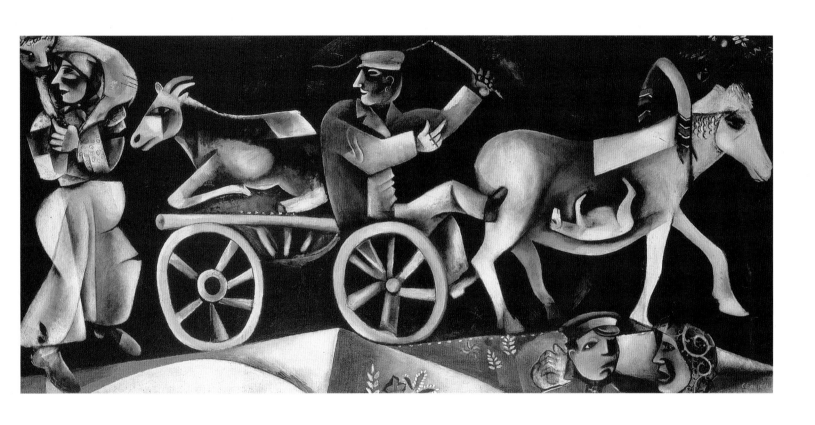

18. ***The Cattle Dealer***
(1912), Oil on canvas,
96 x 200 cm,
Kunstmuseum, Basle.

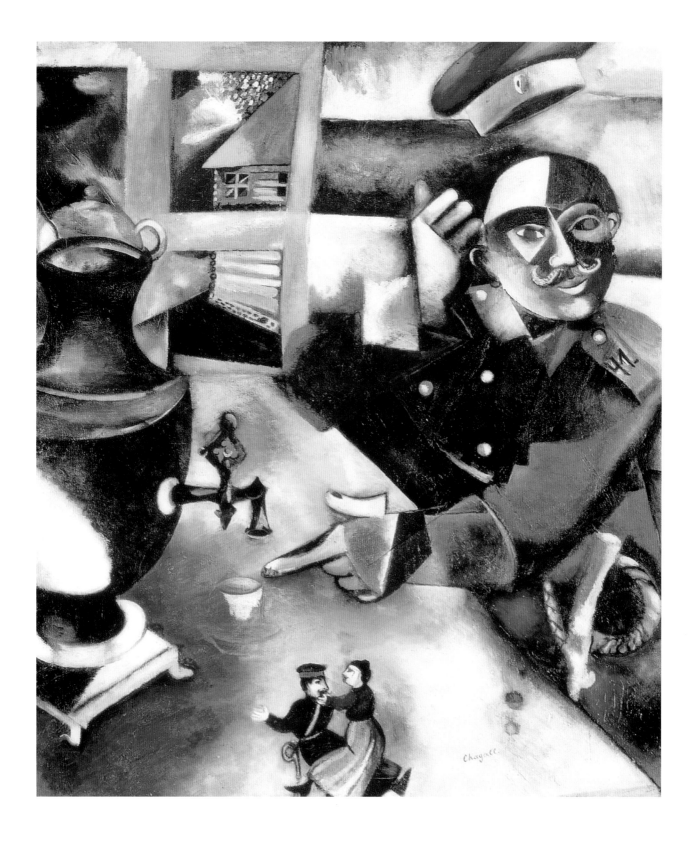

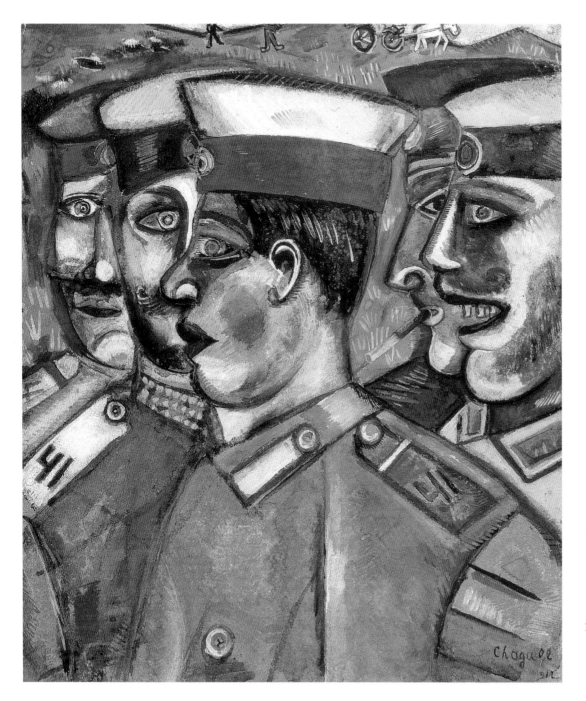

19. ***The Soldier Drinks***
 (1912), Oil on canvas,
 110.3 x 95 cm,
 Guggenheim Museum,
 New York.

20. ***Soldiers*** (1912),
 Gouache on cardboard,
 38.1 x 31.7 cm,
 Private Collection.

Of course Paris also added new themes and new plastic ideas to Chagall's art. The artist not only looked at paintings but got to know people. Talented people were drawn to him, sensing in him a true colleague; thus he became friends with Guillaume Apollinaire, Max Jacob and Blaise Cendrars. Apollinaire was the first to mention Chagall's name in print, in 1911, when the artist exhibited at the Salon des Indépendants. Apollinaire's sharp-edged verses, often blending into type-set hieroglyphic drawings (calligrams), were for the artist a school of clarity and creative courage, a lesson in the daring logic of twentieth-century thought. This found reflection in the famous picture *Hommage à Apollinaire* (1911-1912), in which the figures of a man and a woman form a single whole, both divided and united by Time which is embodied in a slowly revolving circle recalling both the face of a huge clock and the heavenly sphere seen by the alarmed gaze of a twentieth century astrologist.

This decisive apprenticeship in a way of looking was reinforced in some of the studio exercises at La Grande Chaumiere and La Palette, run by Le Fauconnier (whose wife was Russian). But the true formal nourishment for Chagall was to be, according to his own statements, Paris itself; Paris and that extraordinary «Light-Liberty» through which he fulfilled himself as a painter.

From this first Parisian period great masterpieces blossomed forth: *To Russia, Asses and Others* (1911-1912), *Land the Village* (1911), *The Holy Carter* (1911-1912), *Hommage à Apollinaire* (1911-1912), and *Self-portrait with Seven Fingers* (1911). For only now can we fully picture what it meant to paint in Paris this fairytale image of an eternally sorrowful violinist drawn from his childhood recollections; in Paris, crammed with contemporary art and classical art and arguments about the future of art; in Paris, already full of artistic manifestoes, satiated with both elegant and shocking works; in Paris, which had already tasted the aggression of Cubism, the impetuous colour of the Fauves, the Saisons de Diaghilev and the first experiments of the Constructivists.

The first critics, writing about Chagall in the 1920s, correctly noted that Paris gave his painting its own particular nuance, a fragile nervousness and certainty of line, which now began to firmly and precisely resonate the colour, and in many ways to govern it. And the areas of colour, taking on a clarity of outline and, consequently, another level of expression, free themselves from approximation, pouring out with new, disturbing power.

Chagall's palette took on a certain refinement, without losing any of its essential qualities; the emotional and conceptual structures became even richer and more unified, his Paris lessons clearly showing through the highly colourful, fervent fantasy.

21. ***The Violonist*** (1912-1913), Oil on canvas, 184 x 148.5 cm, Royal Collection, The Hague.

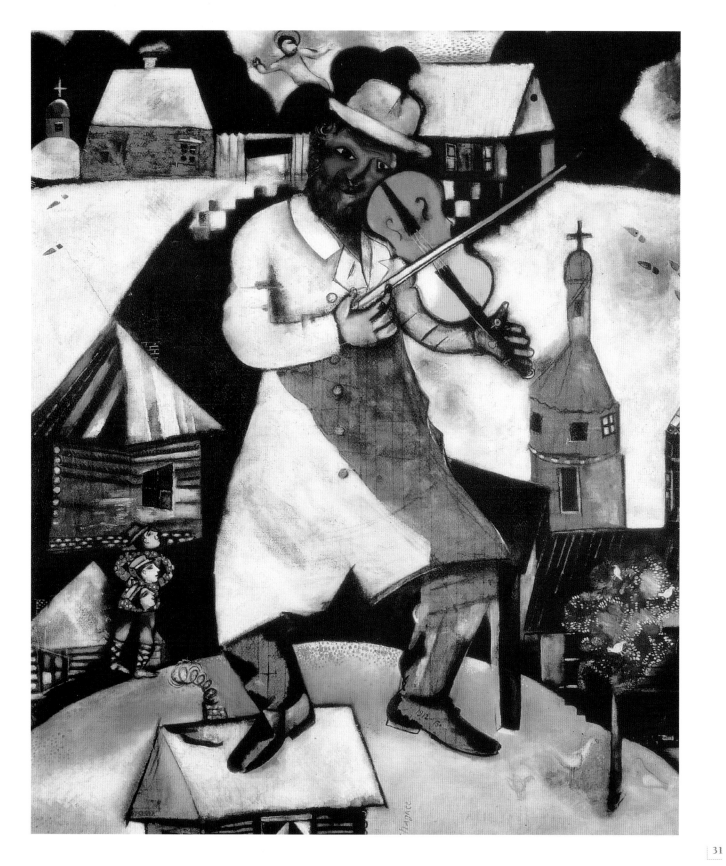

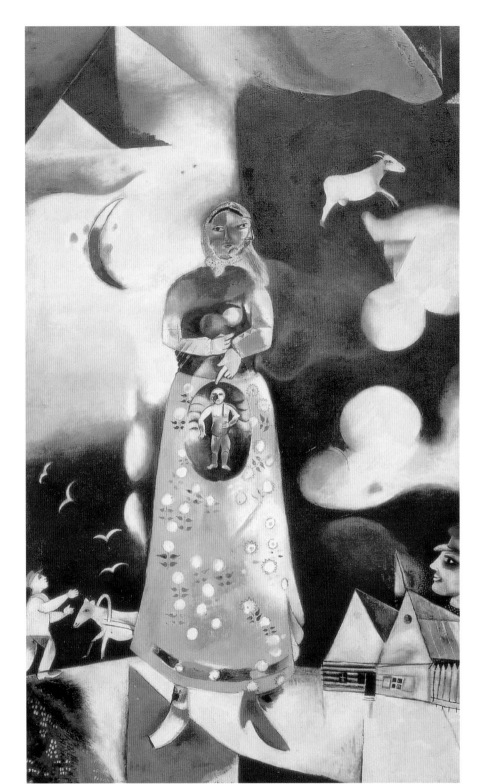

22. *Maternity* (Pregnant
 Woman) (1913),
 Oil on canvas,
 194 x 115 cm,
 Stedelijk Museum,
 Amsterdam.

23. *Self-Portrait with
 White Collar* (1914),
 Oil on cardboard,
 29, 9 x 25,7 cm,
 Philadelphia Museum
 of Art, The Louis
 E. Stern Collection,
 Philadelphia.

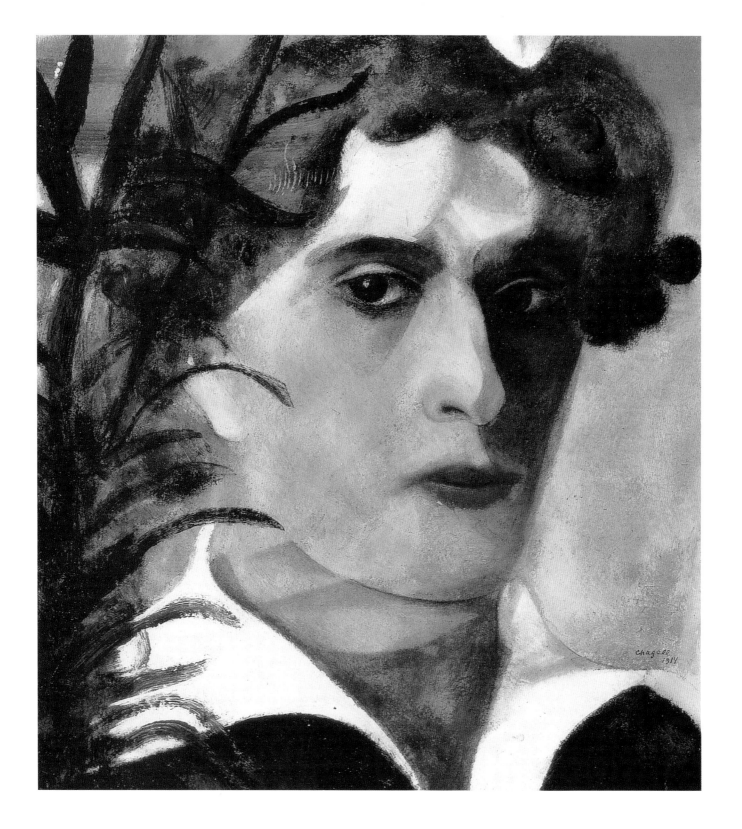

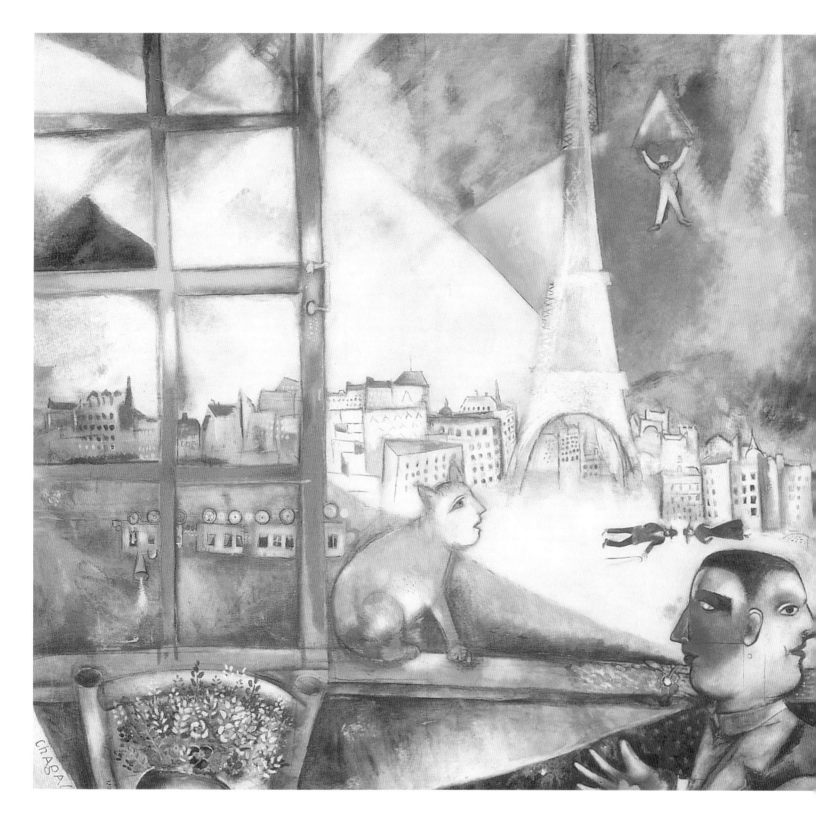

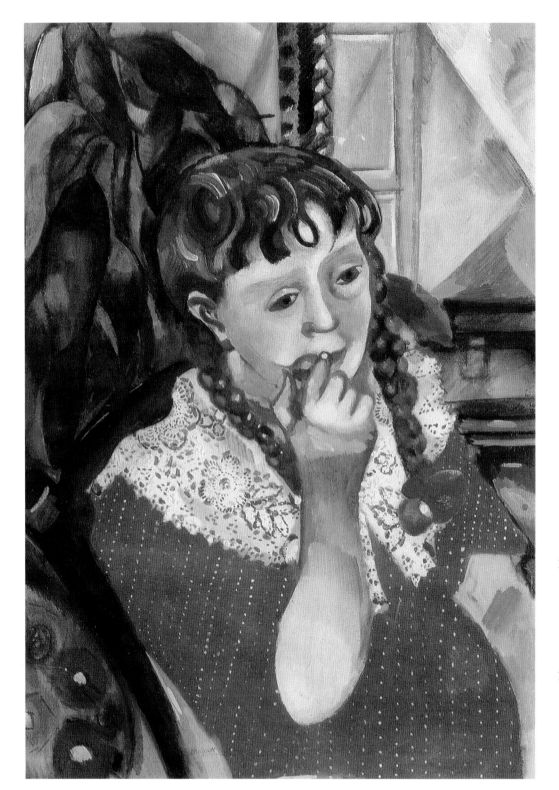

24. *Paris through the
 Window* (1913),
 Oil on canvas,
 132.7 x 139.2 cm,
 Guggenheim Museum,
 New York.

25. *Portrait of the Artist's
 Sister, Maryasinka.*
 (1914), Oil on
 cardboard,
 51 x 36 cm,
 Private Collection,
 St. Petersburg.

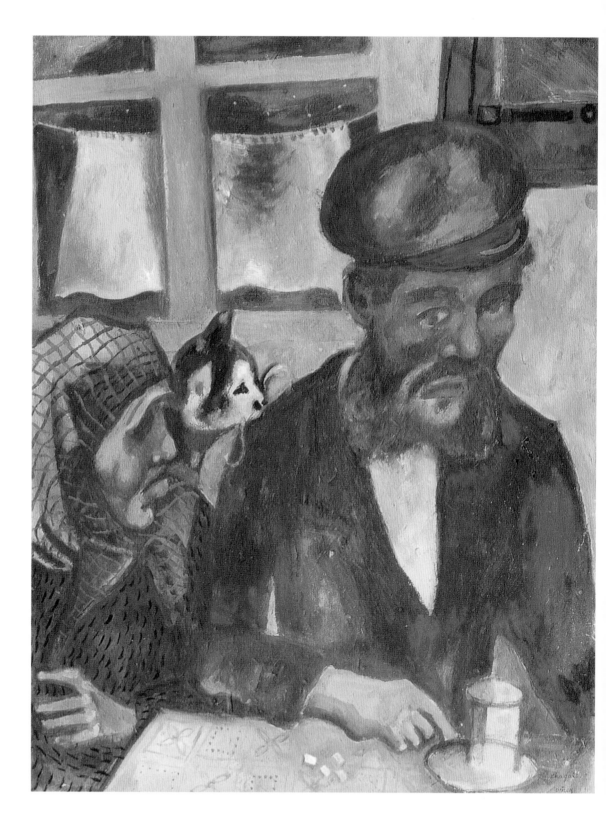

26. ***Father*** (1914),
 Tempera on paper
 mounted on
 cardboard,
 49.4 x 36.8 cm,
 Russian Museum,
 St. Petersburg.

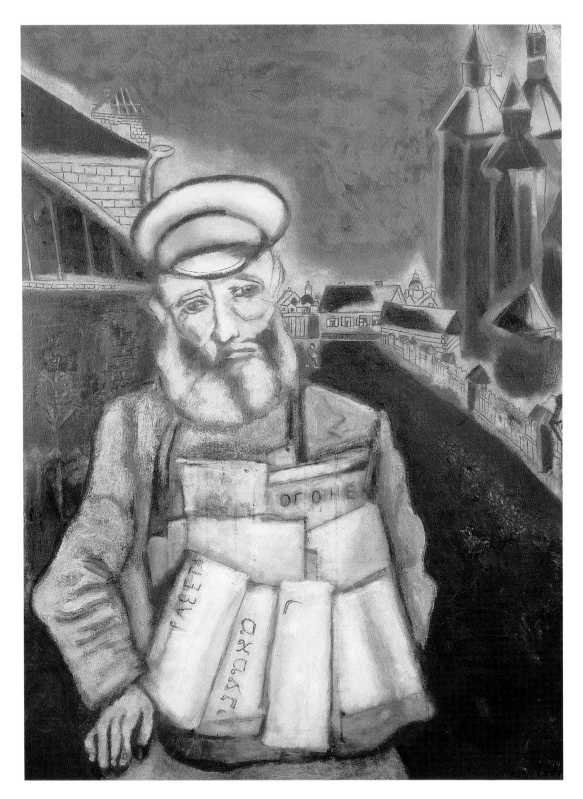

27. ***The Newspaper Vendor*** (1914), Oil on canvas, 98 x 78.5 cm, Collection Ida Chagall, Paris.

It suffices to compare *Birth of a Child* (1911) with the above-mentioned *Birth* (1910). The Paris picture, unlike that painted in Vitebsk, shows the unity of subject, space and genre; there is no complex link between arrested eternity and an everyday scene, or in any case this link is barely perceptible. Here we should note how from picture to picture the objects in Chagall's works are filled with different, metaphorical meaning whilst touchingly preserving their everyday authenticity.

The frenzy of painting which animated Chagall justifies the terms which, later, the poet André Breton employed to describe it in *Genèse et perspective artistiques du surréalisme* (1941): «The total lyrical explosion dates from 1911. It is from this moment that metaphor, with him alone, marks its triumphant entry into modern painting.[6]« This pictorial fulguration which found the path of self-expression was indeed a total lyrical explosion. How could one not be surprised by the miracle of Chagall's painting between 1911 and 1914? How could one not marvel at the obstinate coherence of a creator who mastered the lessons of Fauvism and Cubism only in order to liberate himself from them even more?

Chagall already knew intuitively that colour in its extremes is the bearer of physically tangible values. He had to raise its radiance to the limit, to use its rare sonority. The painter was indebted to the Fauvists, Van Gogh, Gauguin and Matisse, whose works he saw at Bernheim's, for his encounter with absolute colour. To Cézanne and the Cubists he owed the geometric framework of his paintings between 1911 and 1914 and the elements of his plastic grammar. But his individuality resisted all theoretic limits.

«Let them eat their square pears on their triangular tables![7]» he cried vehemently, speaking of the Cubists. A true creator, Chagall borrowed from Cubism only that which served his personal vision. Painting, for this artistic rebel, was above all the flight of the imagination.

The thematic repertory of the works executed between 1911 and 1914 is significant in this regard. Russian subjects mix with those of the ghetto, family figures with those of the village community: *The Wedding* (1910), *Sabbath* (1910), *Grandfather* (1910), *Around the Lamp* (1910), *Birth of a Child* (1911), a theme already treated in 1910, *The Village Under the Moon* (1911), *Dedicated to my Fiancée* (1911), *Praying Jew* (1912-1913), *The Cattle Dealer* (1912), *Maternity* (or the Pregnant Woman; 1913), *To Russia, Asses and Others* (1911-1912) - they all speak of his sadness, of a nostalgia for the land of his birth.

The time has come to speak about what is thought to be Chagall's central work from this post-Parisian period. *About The Mirror* (1915).

28. ***The Barbershop***
(1914), Gouache and oil on paper,
49.3 x 37.2 cm,
Tretyakov Gallery,
Moscow.

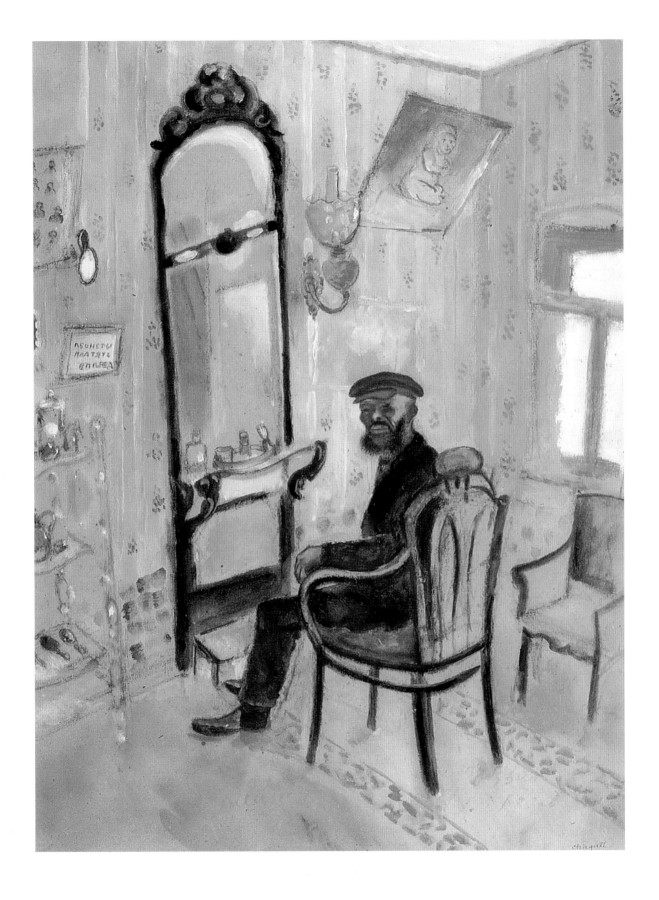

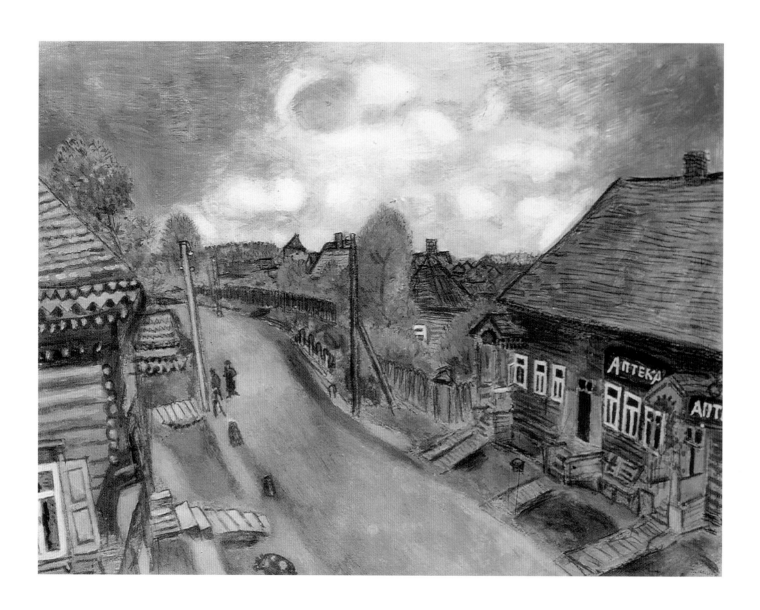

29. ***Chemist's Shop in
 Vitebsk*** (1914),
 Gouache, tempera,
 watercolour and oil on
 paper mounted on
 cardboard,
 40 x 52.4 cm,
 Collection Valery
 Dudakov, Moscow.

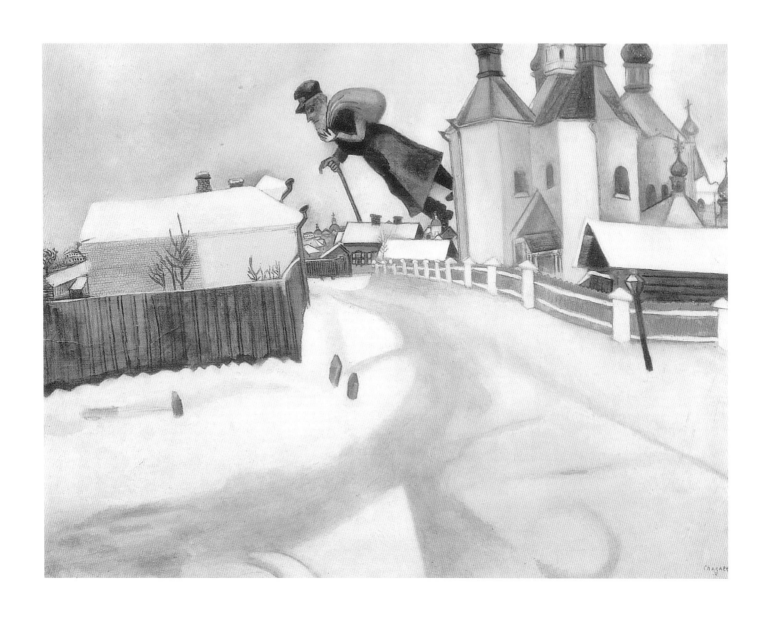

30. *Over Vitebsk* (1914).
Oil on paper,
73 x 92.5 cm,
Collection Ayala and
Sam Zacks, Toronto.

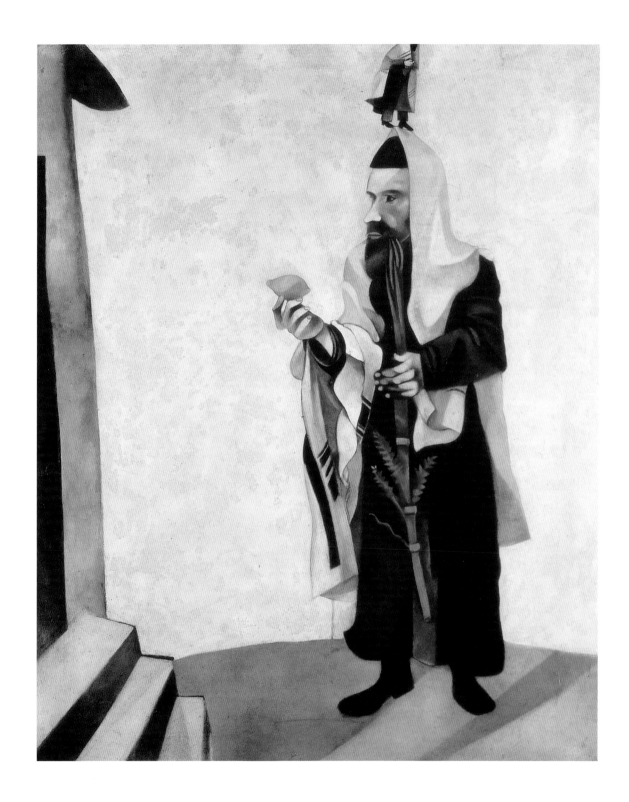

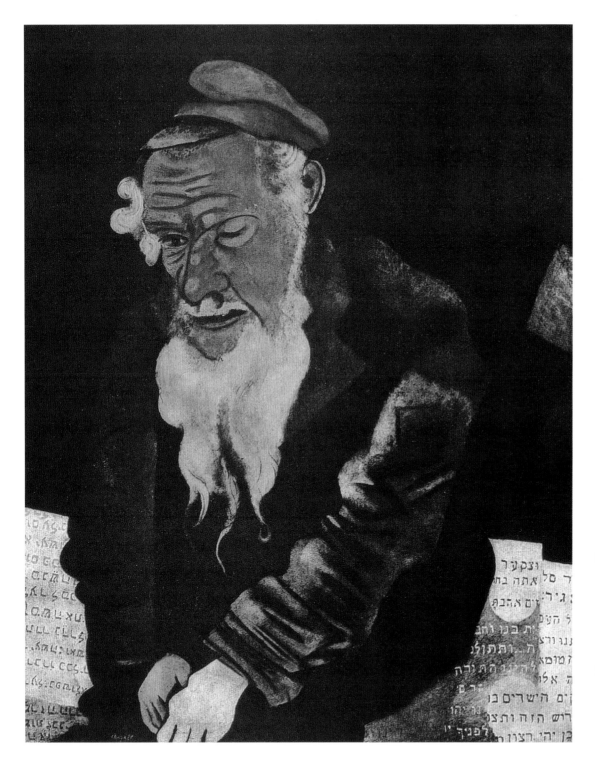

31. ***Feast Day or Rabbi
 with a Lemon*** (1914),
 Oil on canvas,
 100 x 80.5 cm,
 Rosengart Gallery,
 Lucerne.

32. ***Jew in Green*** (1914),
 Oil on cardboard,
 100 x 80 cm,
 Collection Charles im
 Obersteg, Geneva.

«...It's a strange thing - a mirror: a frame, like an ordinary picture, and at the same time in it you can see hundreds of different pictures, both very alive and yet instantaneously disappearing for ever», wrote Chesterton. Could Marc Chagall avoid this motif, he who so intently studied the primordial conceptions of life - Time and Space?

The mirror, extending and broadening the world, is able to shake and change it; the mirror, creating the «double» of the visible and, like any reflection, seeming to enter into an argument with time; the mirror, in which the ordinary world can suddenly - frighteningly and gaily - appear to be foreshortened in strange ways. It attracted Chagall, delighted him and troubled him.

In *The Mirror* we see the meeting between the earlier impressions of Vitebsk, unforgotten but now approached with new penetration, Chagall's Parisian lessons and all the eternal questions - the essence of Time and Space, of the relationship between the small and the great. The work also retains the untroubled child-like perception of happiness and sadness through the prism of myth - at once elevatedly ritualistic and naive. Here everything is material, ordinary and at the same time fantastic. For everything in the picture is created from the substance of art, in other words, the onlooker sees not a counterfeit object, not its illusion, but plastic formulas brought to life and refined to «unprecedented simplicity» (Boris Pasternak).

All these paintings profess themselves totally in the creative tension born of a sense of something lacking, of a paradise lost. They are thus the obstinate attempt to reconstruct a world which the artist snatches away from oblivion, a world freed from the laws of gravity... The process of embodying memory in plastic form can be seen in a picture such as *The Cattle Dealer*, of which Chagall produced two versions (1912 and 1923).

Like his compatriots Mikhail Larionov and Natalia Goncharova, he linked himself on the contrary to the Byzantine tradition, which had always given priority to meaning and not to representation. The extreme elongation of the figures, the rejection of perspective, the plasticity of the interior space, the frontality we often see in his works, the occasional use of red backgrounds as in icons from the Novgorod school, are recognizable objective elements of Chagall's representative system. Certainly the Cubist syntax permitted the painter to give spatial structure to his internal experience in all its multiplicity of different levels. But the «intentionality» of the picture derives from the spiritualist, symbolic culture peculiar to Russia, a mystical land par excellence. Chagall's work had a certain quality - the intuition of a child who believes more in the unseen than in ordinary reality, combined with such great sympathy for the world that he was able to discern even the pain of objects.

33. *The Clock* (1914),
Pencil, gouache and
oil on paper,
49 x 37 cm, Tretyakov
Gallery, Moscow.

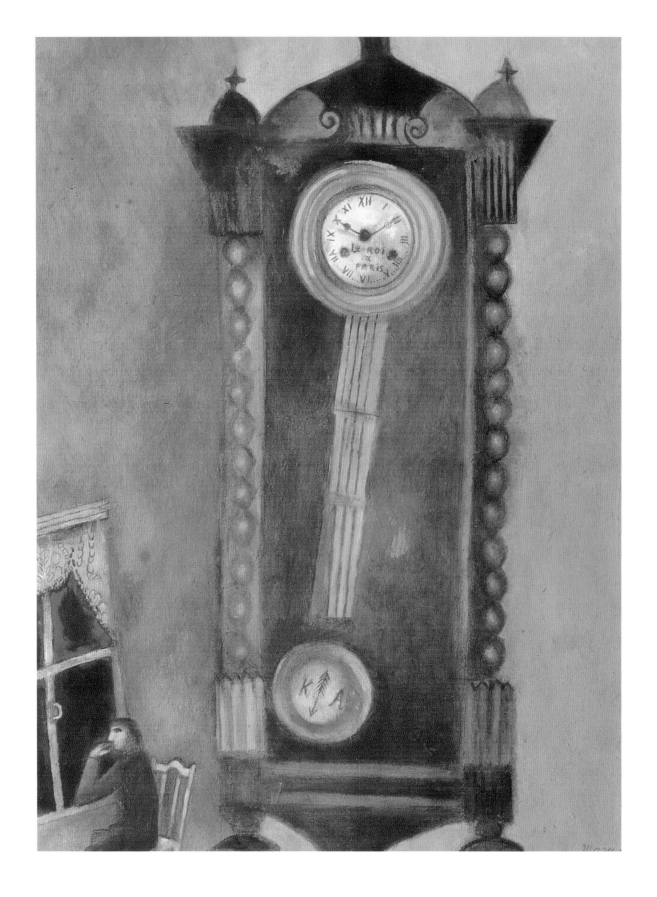

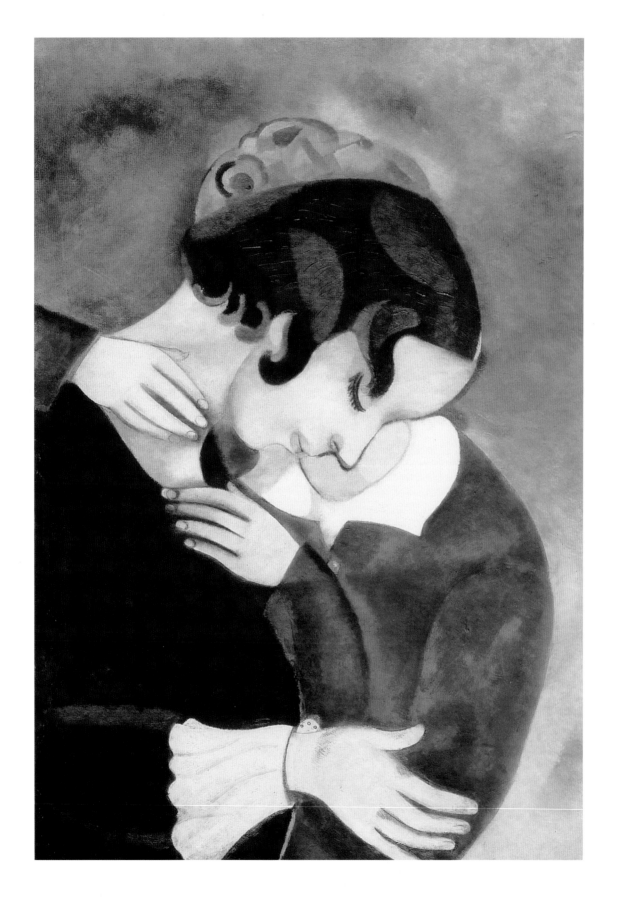

Chagall was not one of those artists whose work had an intellectual basis, a need to pose and solve - if by purely aesthetic means - some theoretical problem. And he was not a captive of the visible world like the Impressionists. His philosophy was intuitive, his archetypal people and situations were inherent in his genetic memory and not acquired. But Chagall, a man who was acutely aware of his own time, paid pointed attention to the past and the future, in so far as those things which above all occupied him in this world - love, death, suffering and happiness - have always existed. It is the external appearance of a rebus of a man who has broken with the natural synthesis of the seen, the known and the unseen: that imaginary synthesis in which fairytale, myth and children's notions of the world in themselves and around themselves fully and harmoniously exist side by side.

The intimate link between man and the universe expresses the profound unity of all living things. This affirmation of the consubstantiality of man and the world is intuitively perceived by Chagall when he writes in *My Life*: "Art seems to me to be above all a state of the soul. The souls of everyone, of all bipeds at all points of the earth, are holy.[8] "

And later, in 1958, Chagall added, in a speech at the University of Chicago: "Life is clearly a miracle. We are parts of this life and we pass, with age, from one form of life to another... A man can never technically or mechanically learn all the secrets of life. But through his soul he is connected with the world, in harmony with it, perhaps even unconsciously.[9]"

We are not far here from the notion of Stimmung.

The second aspect linking Chagall to the dominant artistic currents in contemporary Russia lies in his admiration for Gauguin and his own search for a colour which would give itself up in its totality, for a colour which was pure, original, a colour which was radiant, a colour bearing energy and magic.

In late 1914 and early 1915 three powerful artistic tendencies, each of which was, on its own, extremely significant, took shape and existed side by side in complex interaction in his art. First was that same ordinary life in Vitebsk, enriched with a very slightly more lyrical pensiveness than before and with an echo of French colouring - now barely perceptible, now totally obvious. Second was a clear striving towards the use of poetical and philosophical metaphor as a form of comprehending the most dramatic aspects of life, in which we can trace the development of the central conceptions of his art - Time and Space.

34. *Lovers in Pink*,
Oil on cardboard,
69 x 55 cm,
Private Collection,
St. Petersburg.

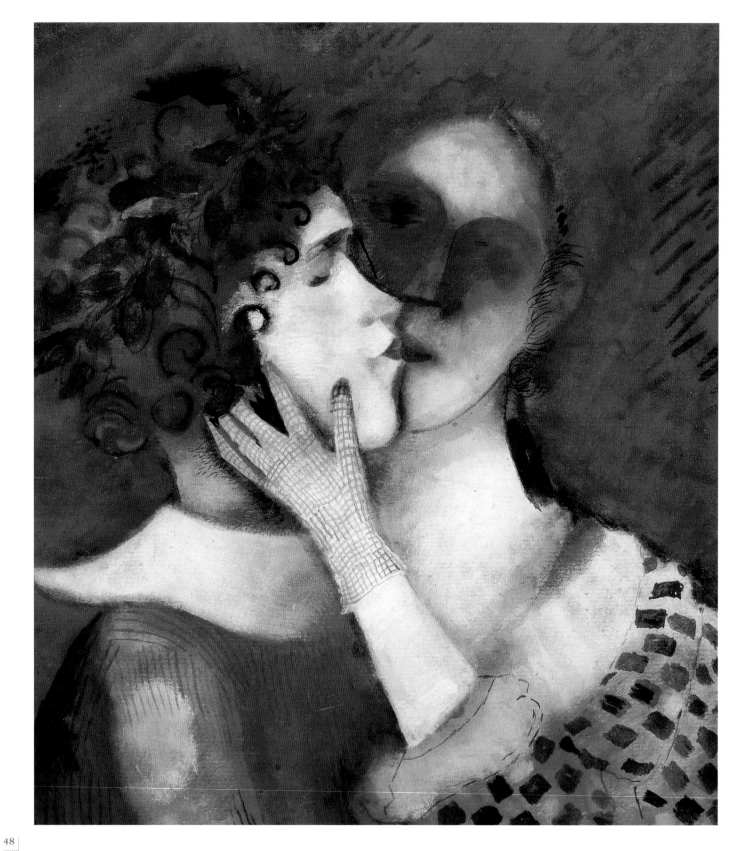

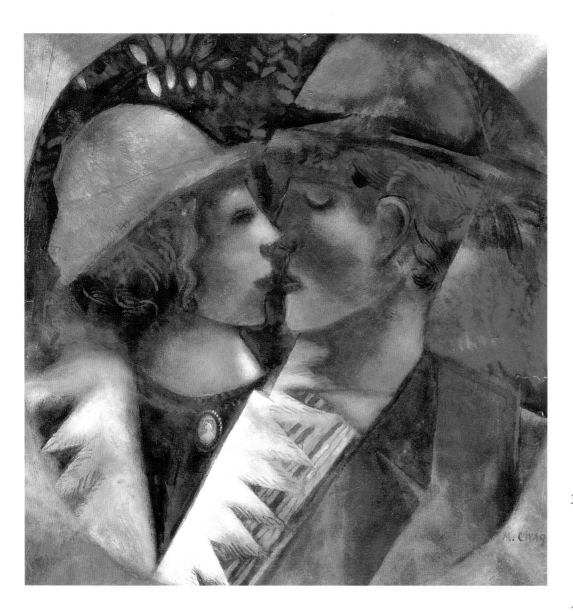

35. ***Lovers in Blue***
(1914),
Oil on cardboard,
48.5 x 44.5 cm.
Private Collection,
St. Petersburg.

36. ***Lovers in Green***
(After 1914),
Oil on cardboard,
48 x 45 cm. Private
Collection, Moscow.

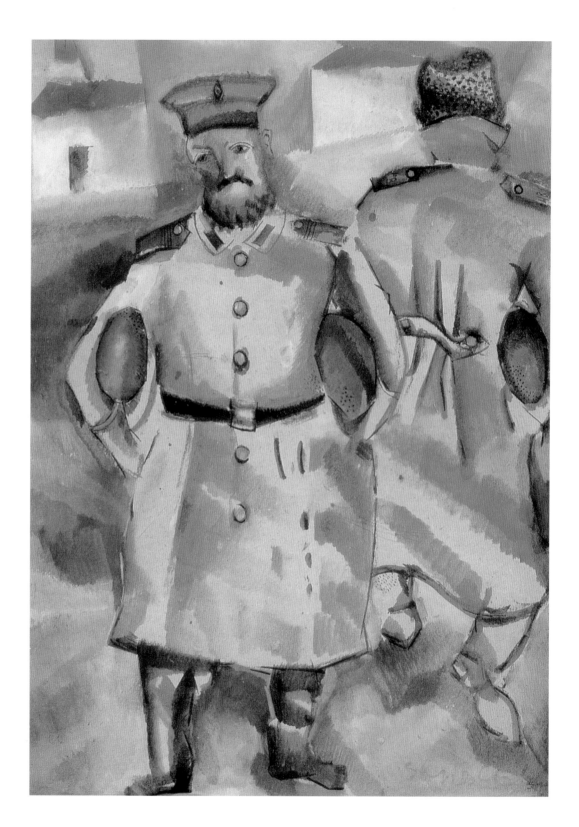

37. ***Soldiers with Bread***
(1914-1915),
Gouache and
watercolour on
cardboard,
50.5 x 37.5 cm,
Collection Zinaida
Gordeyeva,
St. Petersburg.

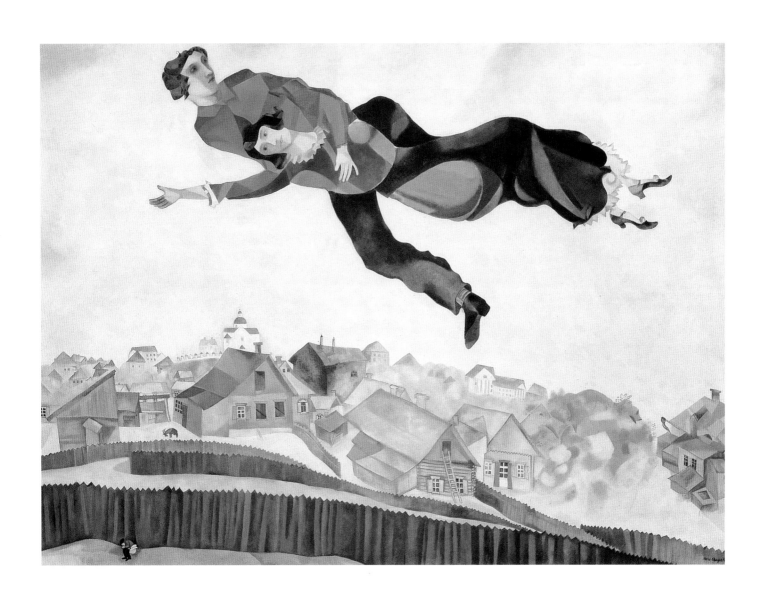

38. ***Over the Town***
(1914-1918), Oil on
canvas, 141 x 198 cm,
Tretyakov Gallery,
Moscow.

Finally, thirdly, it is a marked Symbolistic basis to his work which is seen in a whole series of paintings united by their tense, disturbed and polysemantic subtext and completely defined formal system. It seems that it was at this very time, after his return from Paris, after his contact - still only somewhat fragmentary - with Russian culture, that the artist truly revealed what had been accumulating within him during his years abroad. It was at this very time that it became clear that his artistic perception was even richer and more complex than one could judge from an acquaintance with his Parisian works.

The Revolution was to bring the painter the hope of new dignity and the possibility of his realization as an artist. The declaration of war had in effect brought him back to Vitebsk. He found his native soil, his family again, and married Bella. A daughter, Ida, was soon born. A wealth of personal happiness was added to the promise of universal happiness and the obtaining of the rights of full citizenship.

Chagall believed fervently in the Revolution. He had known Anatoly Lunacharsky in Paris. The latter became Commissar for Cultural Affairs in the first Soviet government in 1917 and helped to put into effect Lenin's vast cultural project for Russia, which was not without similarities to the ideology propagated by the Wanderers during the second half of the nineteenth century. Lunacharsky offered Chagall the post of Commissar for Fine Arts in the Vitebsk region and Chagall accepted with enthusiasm. Art as a principle of the flowering of the individual and as a means of social promotion found in Chagall its most active representative. Untiring, the painter established the basic structures for teaching - a museum, an art school, a revolutionary studio - the prerequisites for this revolution of the soul which he sought to bring about in each of his compatriots. He summoned Dobuzhinsky, his former teacher from the Zvantseva school, Pen himself, Ivan Puni and El Lissitzky.

For the first anniversary of the October Revolution he made «art descend into the streets» and transformed the urban decoration of Vitebsk with a sense of the mise-en-scène which he later was to express in his works for the theatre and, above all, the ballet.

39. *The Mirror* (1915),
Oil on cardboard,
100 x 81 cm,
Russian Museum,
St. Petersburg.

This period, although exciting, was to be marked by the conflict with Malevich. There is little evidence to give us an account of this confrontation: Chagall spoke of it only in a roundabout way in *My Life*. But an examination of the aesthetic path taken by each of the two artists makes it clear that antagonism was inevitable.

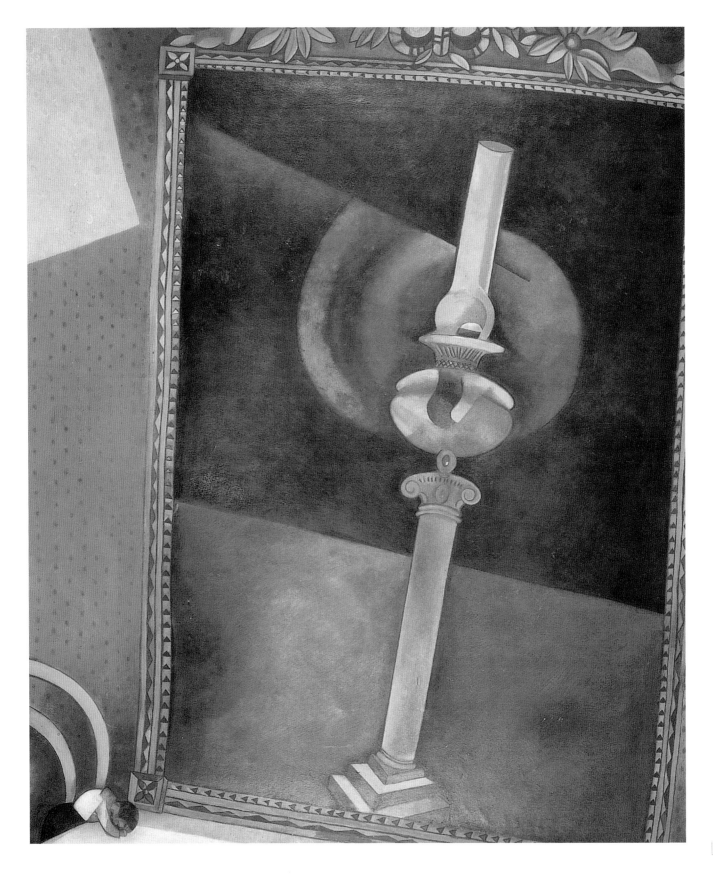

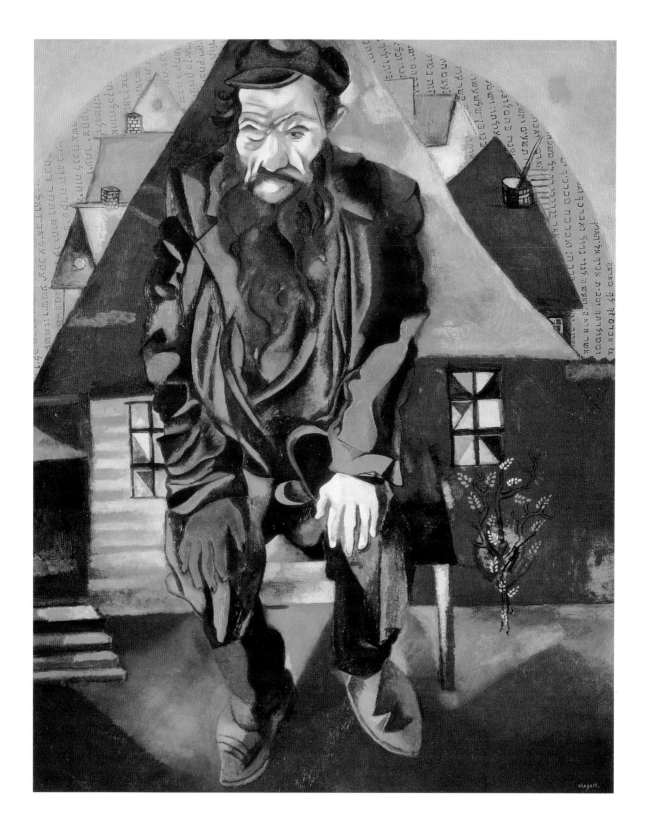

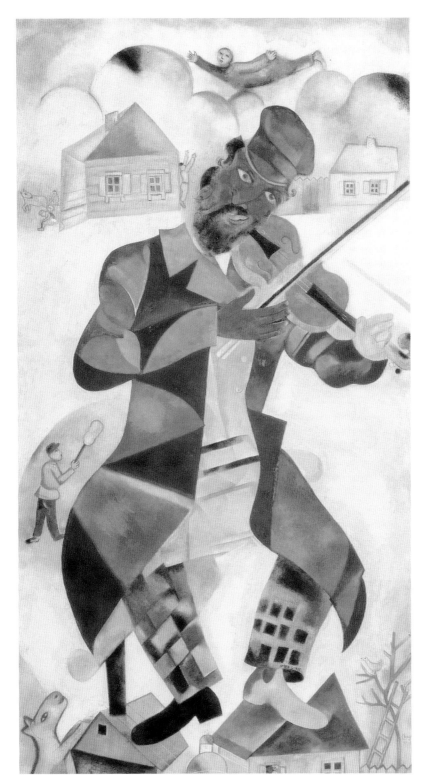

40. *Jew in Red* (1915),
 Oil on cardboard,
 100 x 80.5 cm,
 Russian Museum,
 St. Petersburg.

41. *The Green Violonist*
 (1915) Oil on canvas,
 195.6 x 108 cm,
 Guggenheim Museum,
 New York.

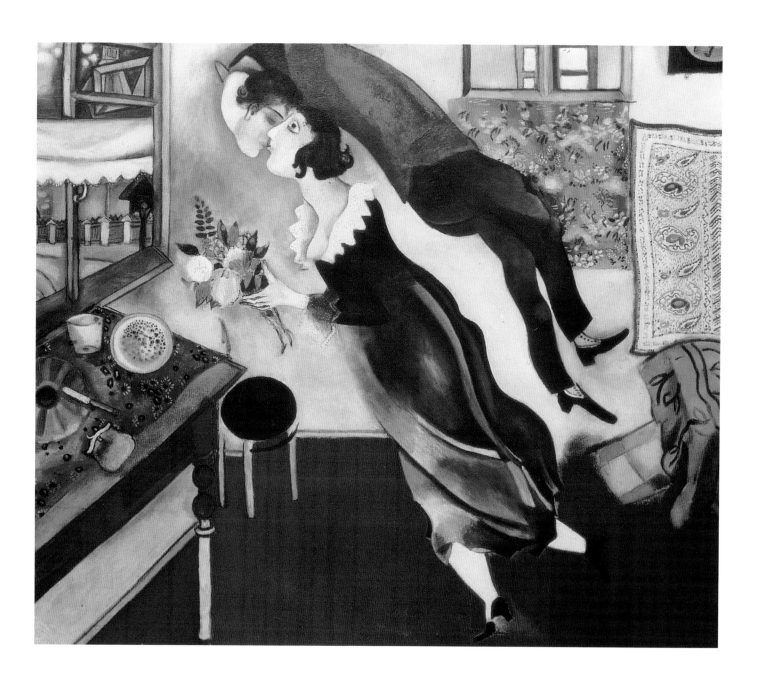

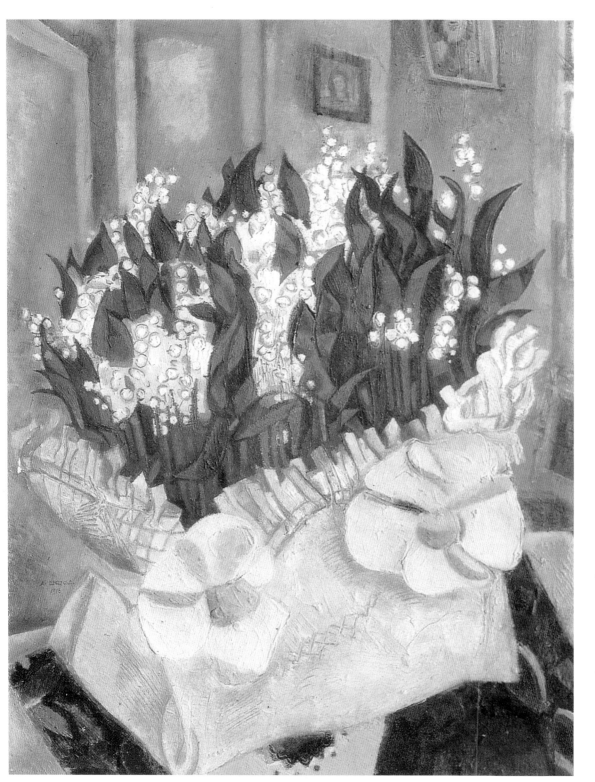

42. **Birthday** (1915-1923),
 Oil on cardboard,
 30.6 x 94.7 cm,
 Guggenheim Museum,
 New York.

43. **Lilies of the Valley**
 (1916),
 Oil on cardboard,
 42 x 33.5 cm,
 Tretyakov Gallery,
 Moscow (gift of
 George Costakis).

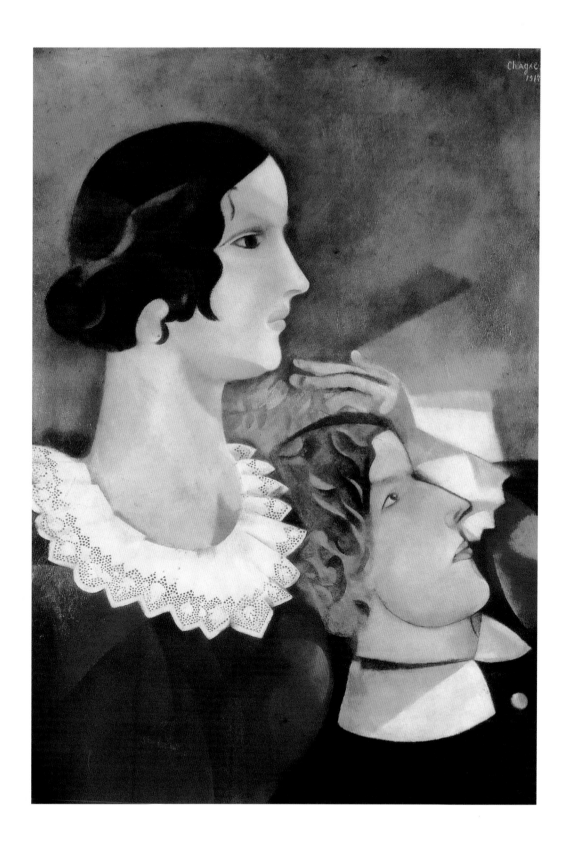

44. *Lovers in Grey*
(1916),
Oil on cardboard,
69 x 49 cm, Collection
Ida Chagall, Paris.

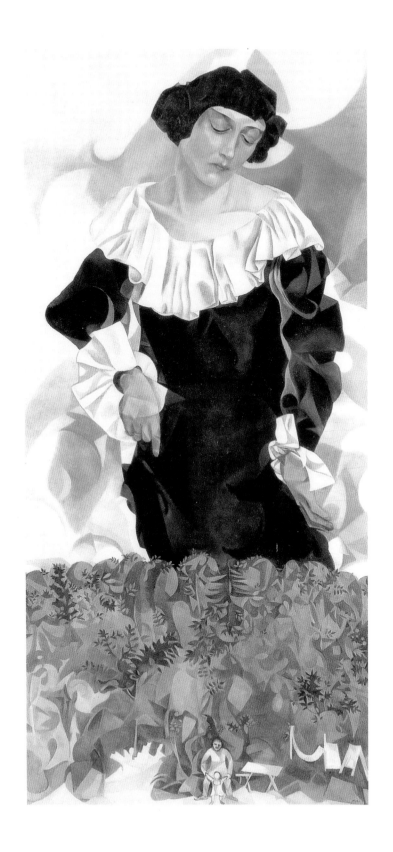

45. ***Bella with a White
 Collar*** (1917), Oil on
 canvas, 149 x 72 cm,
 Collection the artist's
 family, France.

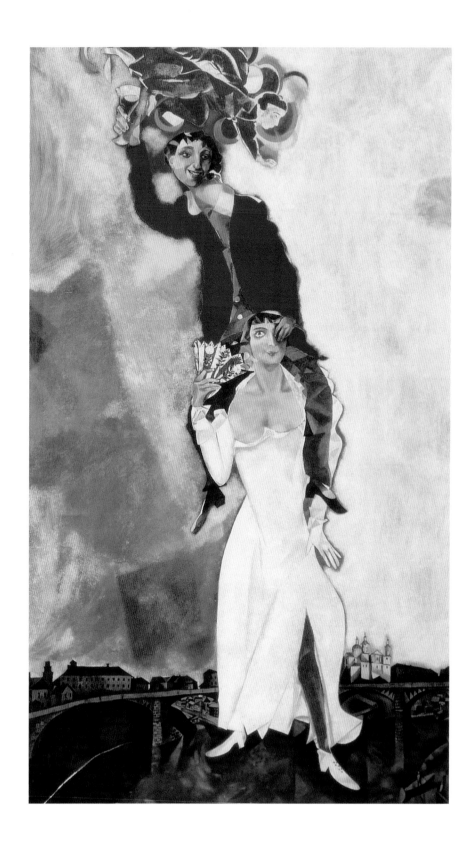

46. *Double Portrait with a Wineglass* (1917),
Oil on canvas,
233 x 136 cm,
Musée National d'Art
Moderne, Paris.

47. *The Promenade*
(1917), Oil on canvas,
170 x 163.5 cm,
Russian Museum,
St. Petersburg.

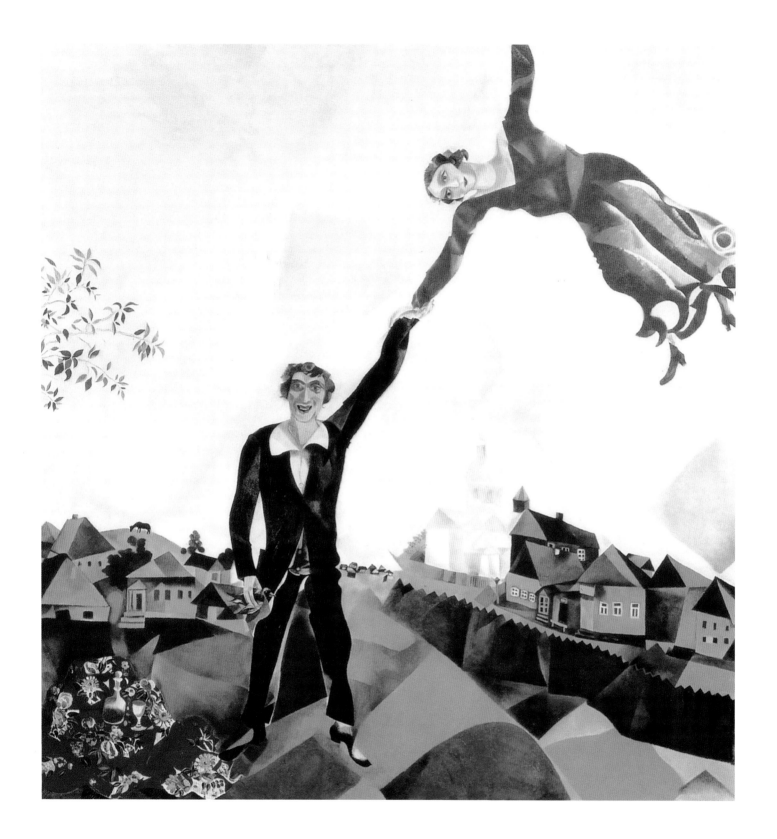

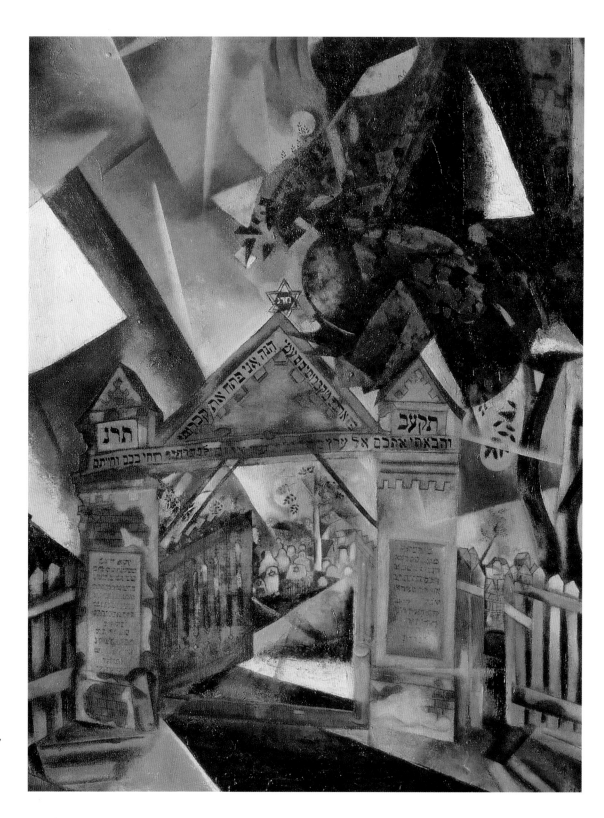

48. *The Cemetery Gates*
(1917), Oil on canvas,
87 x 66.5 cm,
Collection Ida
Chagall, Paris.

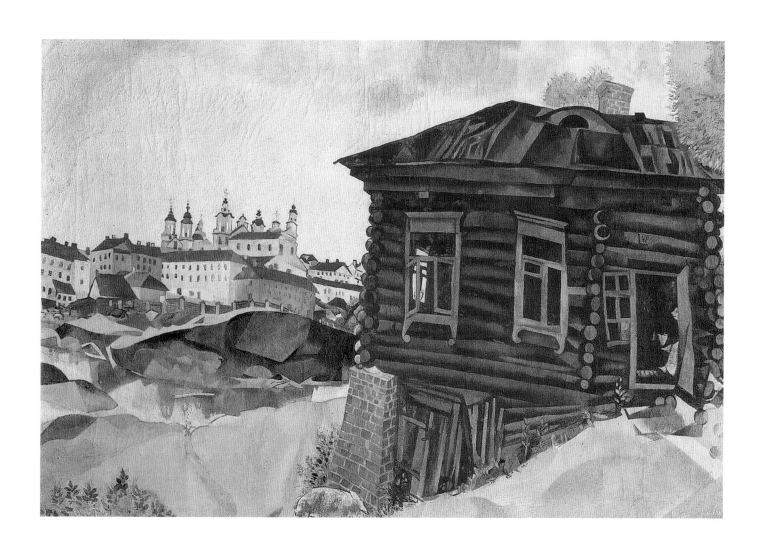

49. ***The Blue House***
(1917-1920),
Oil on canvas,
66 x 97 cm,
Musée des Beaux-
Arts, Liège.

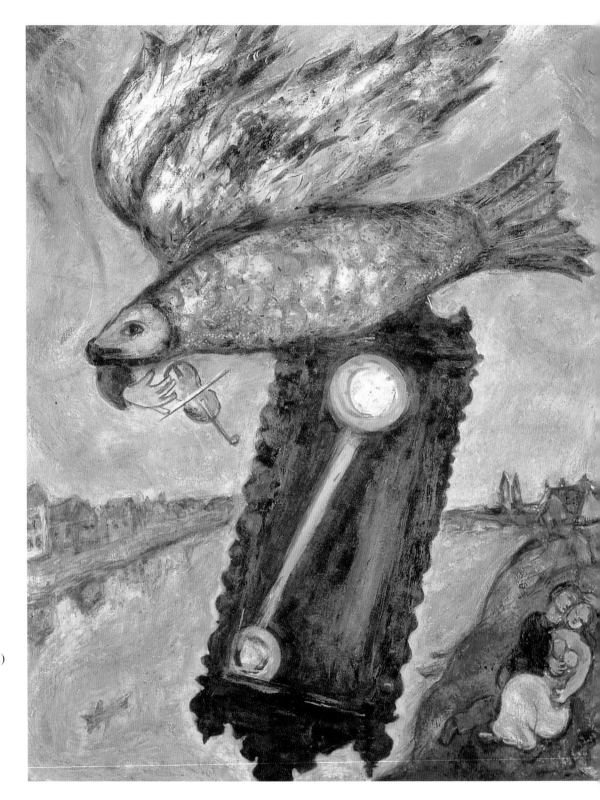

50. ***Time is a River
without Banks***
(1930-1939),
Oil on canvas,
Collection Ida
Chagall, Paris.

51. ***Self-Portrait with
muse*** (*The Apparition*)
(1917-1918),
Oil on canvas,
148 x 129 cm,
Collection Zinaida
Gordeyeva,
St. Petersburg.

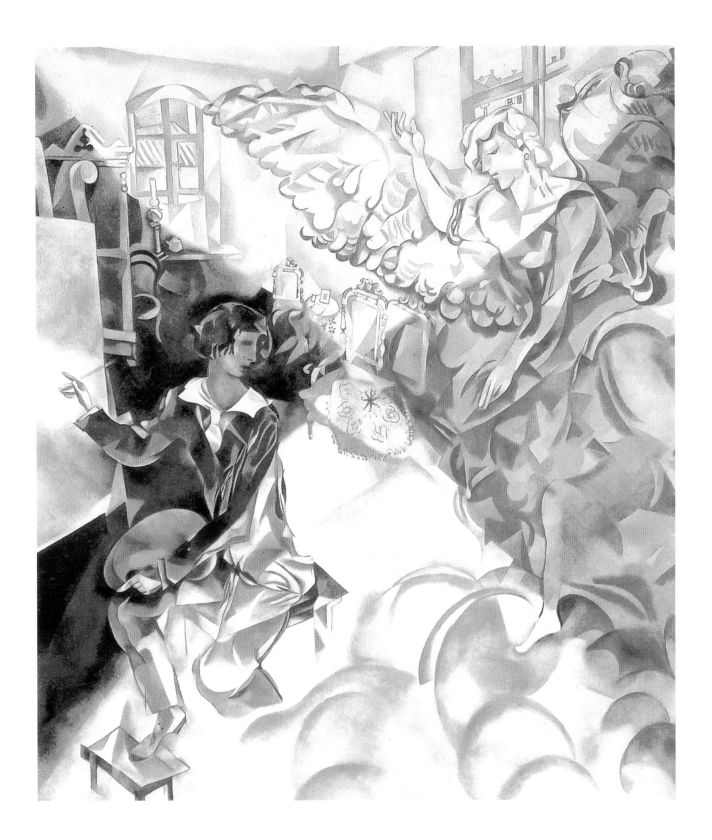

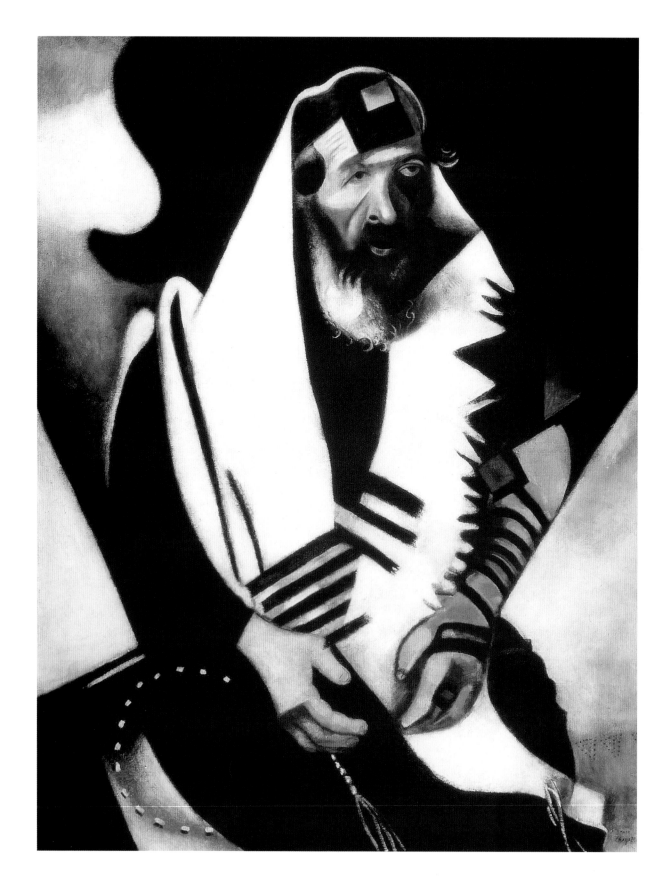

When, in fact, Malevich was invited by the students of the Art School in Vitebsk - Chagall states, moreover, that this was on his initiative - he was already a famous artist who had formulated the basis of his Suprematist doctrine.

The beginning of the year saw the organization of the 10th All-Russia Exhibition «Non-objective Creation and Suprematism», at which Malevich showed his *White Square*. Malevich violently attacked Chagall for his teaching principles and the nature of his art, which he contemptuously charged with naturalism. Malevich's temperament, excessive and at times violent, was in sharp contrast to that of Chagall. Did Malevich also - with his Polish Catholic origins - have an instinctive distrust of the Slavic Jew? Chagall, in his turn rebelling against any theorization of art, did not understand Malevich's aesthetic commitment. At the end of 1919 Chagall was forced to leave Vitebsk, and Malevich set up the group UNOVIS - Affirmation of New Art. The avant-garde thus drove Chagall away in the name of their radical ideas. The disappointment made a deep wound.

In 1922 he was forced into exile, as if his destiny as an artist could not fulfil itself except through the bitter experience of a man wrenched from his own country. Chagall's life was henceforth embodied in the destiny of a painter who literally lived painting, his creation perpetually renewed in the certainty of its own being.

Even the most attentive and partial observer is at times unable to distinguish the "Parisian", Chagall from the «Vitebskian». The artist was not full of contradictions, nor was he a split personality, but he always remained different; he looked around and within himself and at the surrounding world, he used his present thoughts and his recollections. He had an utterly poetical mode of thought which enabled him to pursue such a complex course. In essence, Chagall's approach was something akin to the wise naivety of Shakespeare's plays, in which the hero passes naturally from prose to poetry. At one and the same time (if not on one and the same canvas) he created both an elevated metaphorical world and a benign yet sarcastic picture of everyday life in Vitebsk, decisively standing aloof from systems and declarations and not joining any particular group.

Chagall was endowed with a sort of stylistic immunity: he enriched himself without destroying anything of his own inner structure. Admiring the works of others he studied them ingenuously, ridding himself of his youthful awkwardness, yet never losing his "Archimedes" point for a moment. At times the painter seemed to look at the world through the magic crystal - overloaded with artistic experimentation - of the Ecole de Paris.

52. *Praying Jew* (1923),
Oil on canvas,
116.9 x 88.9 cm,
The Art Institute of
Chicago, Chicago (IL).

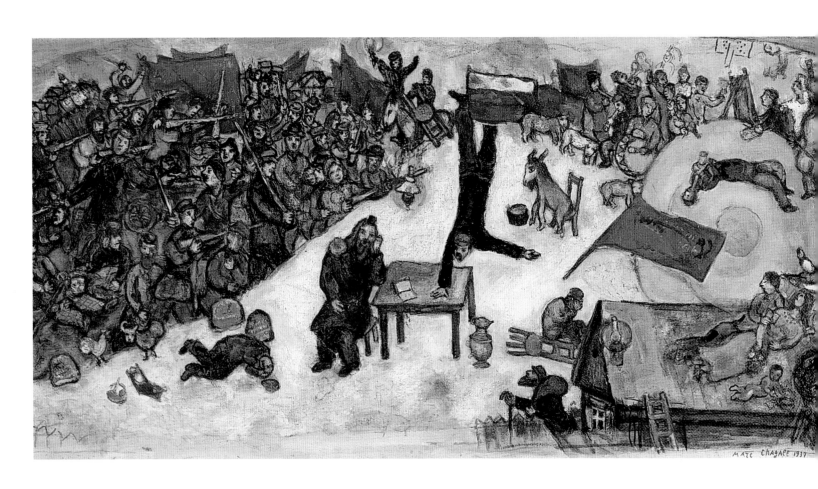

53. **The Revolution**
 (1937), Oil on canvas,
 49.7 x 100.2 cm,
 Musée National d'Art
 Moderne, Centre
 Georges Pompidou,
 Paris.

In such cases he would embark on a subtle and serious play with the various discoveries of the turn of the century and turned his prophetic gaze like that of a biblical youth, to look at himself ironically and thoughtfully in the mirror which naturally and totally uneclectically reflected the painterly discoveries of Cézanne, the delicate inspiration of Modigliani and complex surface rhythms recalling the experiments of the early Cubists (*Self-portrait at the Easel*, 1914). Was this a conscious experimentation with all the lessons of others, so that by comprehending them yet remaining himself he would comprehend himself?

Despite the analyses which nowadays illuminate the painters Judaeo-Russian sources, the formal relationships, inherited or borrowed but always sublime, there is always some share of mystery in Chagall's art. The mystery perhaps lies in the very nature of his art, which uses the experience of memories. Painting truly is life, and perhaps life is painting.
The art of Chagall is inscribed in the flow of temporality, in the unfolding of a creative reverie demanding conscious effort for its embodiment.

Chagall was one of the first artists of our century to perceive and depict what is now usually called the iconosphere as an essential part of nature, as tangible for the artist as the objective, material world.
Sensing the true iconosphere of time and not shunning it, he listened above all to himself; in his picture we see the directness of the storyteller who is able to interrupt himself, to be shocked by his own words or to laugh at them.

It is not without significance that Chagall's painting summons musical terms from the pen of the critic or the historian. Figures and motifs are perceived as so many sonorous objects, colours as rhythms and lines as melodies, the metaphor closely fits the painting because, like the latter, it brings out the conception of time.

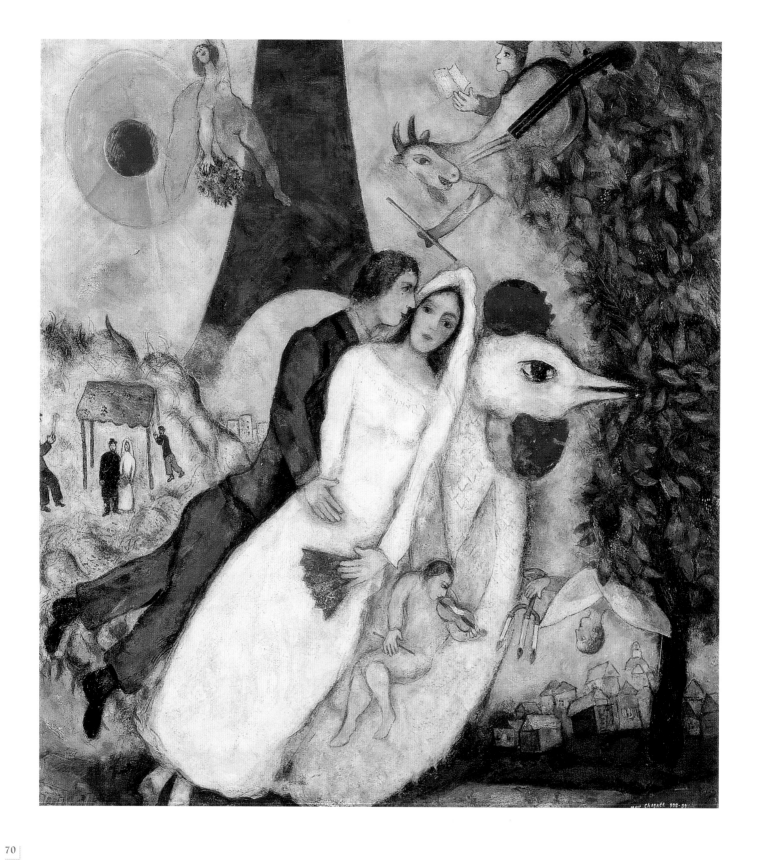

CHRONOLOGY OF THE LIFE AND WORK OF MARC CHAGALL

7 July 1887

Marc Zakharovich Chagall, the son of a fish vendor, was born in Vitebsk.

1906

Studied at the art school of Yuri Pen in Vitebsk, leaving for St. Petersburg in the winter.

1907-1910

Studied at the Drawing School of the Society for the Encouragement of the Arts, St. Petersburg (then directed by Nicholas Roerich) and the private school of S. Saidenberg; entered the private art school of Yelizaveta Zvantseva, where he studied under Léon Bakst and Matislav Dobuzhinsky. Showed his works at the school exhibition held in the office of the magazine *Apollon*.

1910-1914

Lived in Paris, on the Impasse du Maine. In 1911, moved to La Ruche. Met Pablo Picasso, Georges Braque, Fernand Léger, Amedeo Modigliani, Alexander Arkhipenko, Guillaume Apollinaire, Max Jacob, Blaise Cendrars, and other famous artists and writers. Exhibited at the Salon des Independants and the Salon d'Automne in Paris, with the Donkey's Tail group in Moscow, at Der Sturm Gallery in Berlin (first one-man show) and also in St. Petersburg and Amsterdam. On the eve of the war, returned to Vitebsk.

July 1915

Married Bella Rosenfeld.

1915-1917

Worked in Petrograd, served on the military-industrial committee. Exhibited in Moscow and Petrograd.

1916

Birth of his daughter Ida.

1918-1919

Appointed Commissar for the Arts in the Regional Department of People's Education in Vitebsk. Set up and ran (from early 1919) an art school in Vitebsk, where the teachers included Mstislav Dobuzhinsky, Ivan Puni and Kasimir Malevich. Headed the Free Painting Workshop (Svomas) and the museum. Organized the celebrations in 1918 for the first anniversary of the October Revolution. Took part in the First State Free Exhibition held in the Winter Palace, Petrograd.

54. *The Couple of the Eiffel Tower* (1938-1939), Oil on canvas, Musée National d'Art Moderne, Centre Georges Pompidou, Paris.

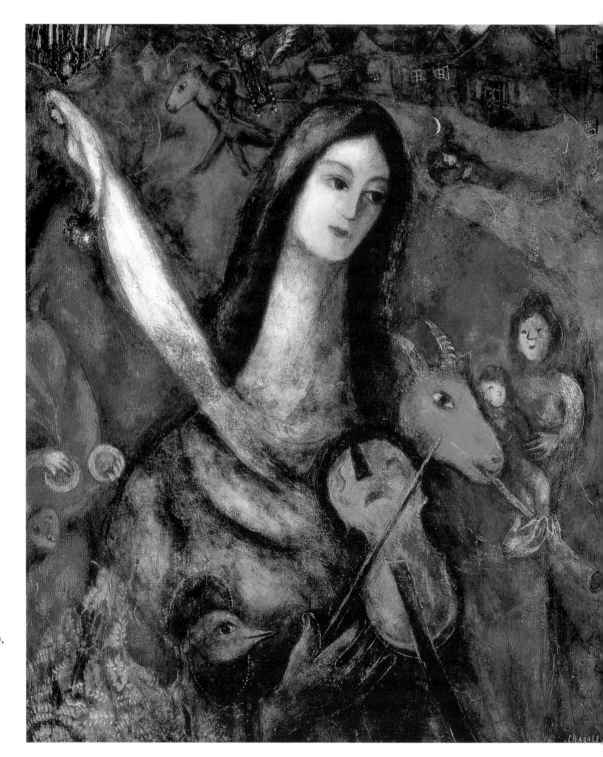

55. ***Blue Concert*** (1945),
 Oil on canvas,
 124.5 x 99.1 cm,
 Private Collection,
 Acquavella Galleries,
 New York.

56. ***The Apparition of the
 Artist's Family*** (1947),
 Oil on canvas,
 123 x 112 cm,
 Musée National d'Art
 Moderne, Centre
 Georges Pompidou,
 Paris.

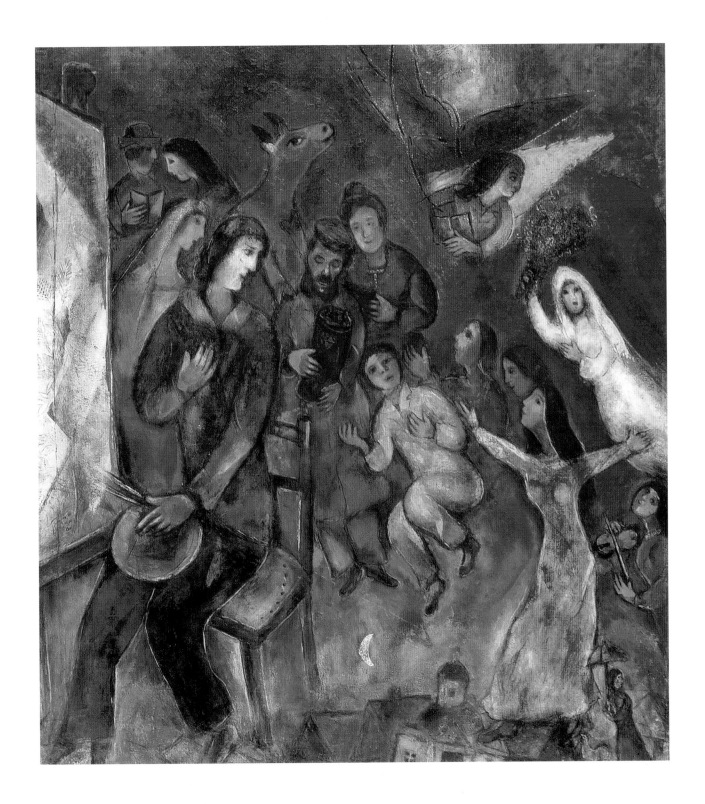

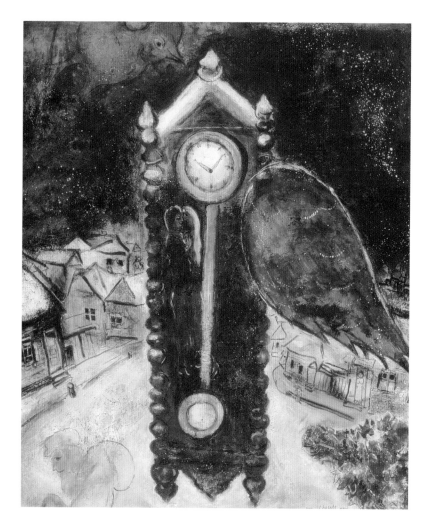

57. **Wall-clock with a Blue Wing** (1949), Oil on canvas, 92 x 79 cm, Collection Ida Chagall, Paris.

58. **Champ de Mars** (1954-1955), Oil on canvas, 149.5 x 105 cm, Museum Folkwang, Essen.

1920-1921

Conflict with Malevich and Lissitzky forced Chagall to leave Vitebsk. He lived in and near Moscow, producing works for the Jewish Chamber Theatre and teaching in the Malakhovka and Third International colonies for homeless children. Began work on the book *My Life*.

1922

Joint exhibition in Moscow with Nathan Altman and David Sterenberg.

1922-1923

Travelled to Kaunas with an exhibition of his works. Visited Berlin and Paris. Settled in Paris in September 1923. Produced etchings for *My Life* and began work on illustrations to Gogol's *Dead Souls*.

1926

One-man shows in Paris and New York.

1930-1931

Worked on illustrations to the Bible. Travelled to Switzerland, Palestine, Syria and Egypt. Exhibitions in Paris, Brussels and New York.

1933

At Goebbels' command, Chagall's works were burnt in public in Mannheim. Exhibition in Basle.

1935

Visited Poland.

1937

Granted French citizenship. Travelled to Italy.

1939

Carnegie Prize (USA).

1940

Moved to the Loire and then to Provence.

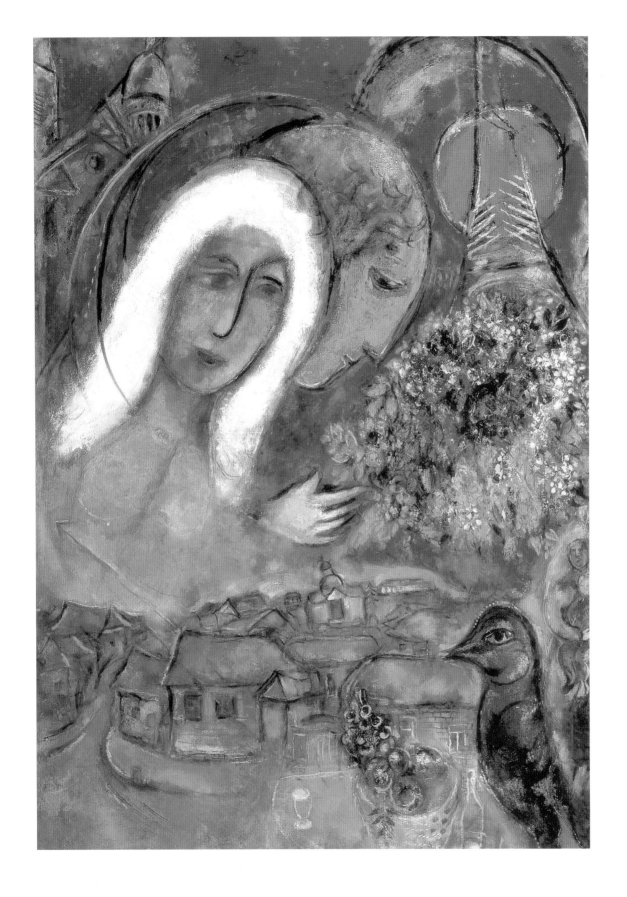

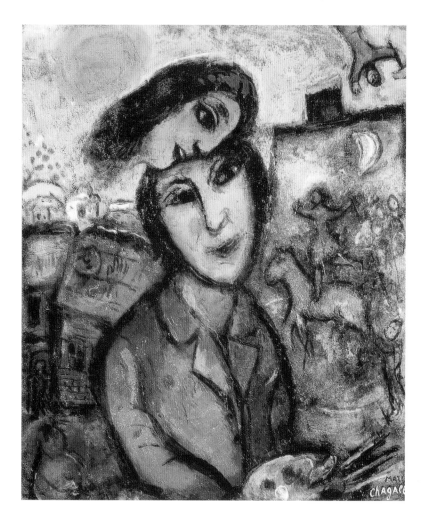

59. *The Artist at his Easel*
(1955), Oil on canvas,
55 x 46 cm, Private
Collection.

60. *The Triumph of the
Music* (1967), Oil on
canvas (wall painting),
about 11 x 9 m,
The Metropolitan
Opera, Lincoln Center,
New York.

1941

Arrested in Marseille and then freed. Moved
to the USA.

1942

Worked for theatres in the USA and Mexico.

1944

Death of Bella Chagall in New York.

1945

Set designs and costumes for Stravinsky's
ballet *The Firebird*.

1946

Exhibitions in New York and Chicago.

1947

Exhibition at the Musée National d'Art
Moderne in Paris.

1948

Returned to France. Publication of *Dead Souls*
with illustrations by Chagall. Exhibitions in
Amsterdam and London. Travelled widely in
this and the following years.

1950

Moved to Vence, near Nice. Worked on
lithographs and ceramics.

1951

First stone sculptures. Large exhibitions in
Bern and Jerusalem.

1952

Married Valentina Brodsky. Visit to Greece.

1953-1955

Major exhibitions in Turin, Vienna and Hanover.

1956

Publication of the Bible with illustrations by
Chagall.

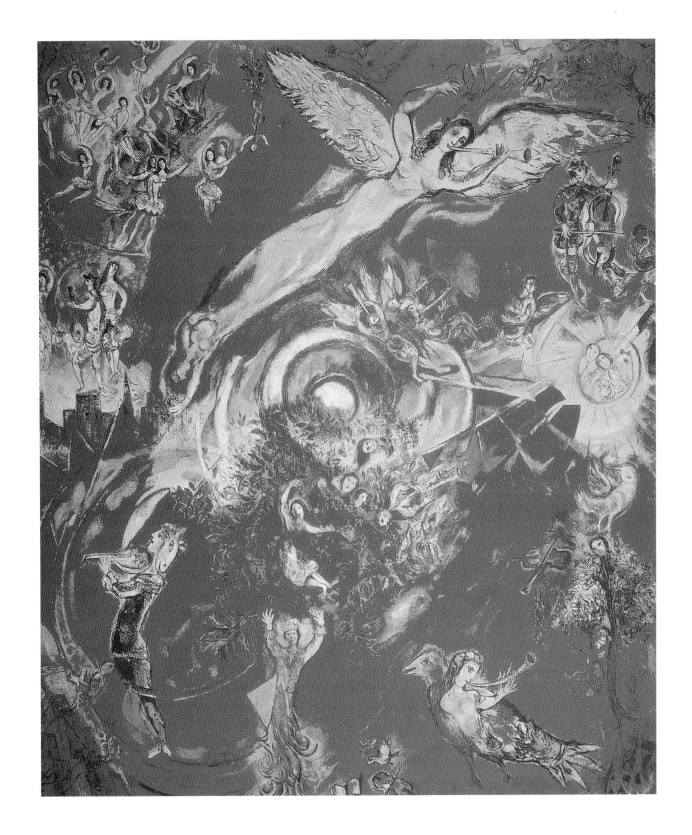

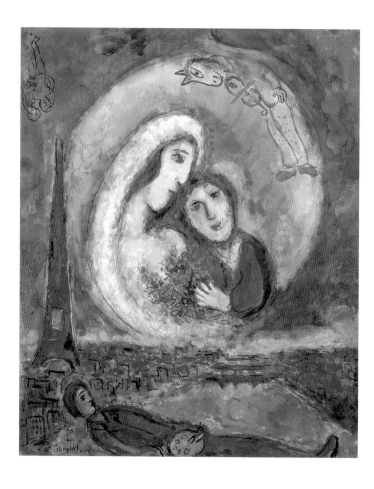

61. ***The Painter*** (1976)
Oil on canvas,
65 x 54 cm,
Private Collection.

62. ***The Dream*** (1978)
Tempera on canvas,
65 x 54 cm,
Private Collection.

1957

Began work on stained-glass windows (for Assy, Metz, Jerusalem, New York, London, Zurich, Reims, Nice). Exhibitions of graphic works in Basle and Zurich.

1959

Murals in the foyer of the Theatre in Frankfurt am Main. Exhibitions in Paris, Munich and Hamburg.

1963

Exhibitions in Japan.

1964

Ceiling paintings in the Opera in Paris. First mosaics and tapestries.

1966

Moved to Saint-Paul-de-Vence. Painted murals in the Metropolitan Opera in New York.

1969-1970

Foundation of the Musée Chagall in Nice. Major retrospective exhibition at the Grand Palais in Paris.

June 1973

Trips to Moscow and Leningrad at the invitation of the USSR Ministry of Culture.

July 1973

Opening of the Musée Chagall in Nice.

October 1977

Exhibition of paintings produced between 1967 and 1977 in the Louvre.

1982-1984

Major exhibitions in Stockholm, Copenhagen, Paris, Nice, Rome and Basle.

28 March 1985

Marc Chagall died at Saint-Paul-de-Vence in the ninety-eighth year of his life.

1987

Major exhibition of Chagall's works in Moscow.

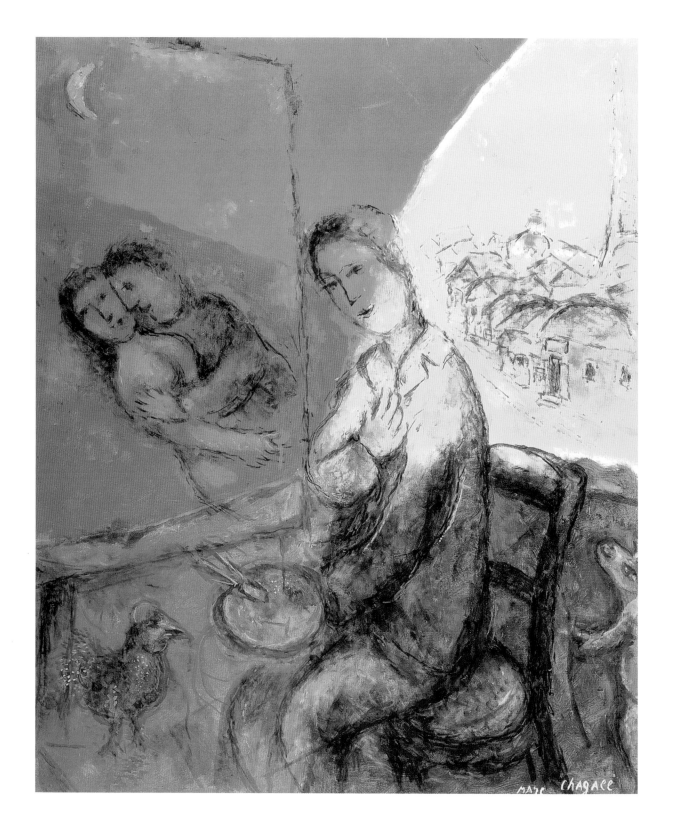

LIST OF ILLUSTRATIONS

NOTES

[1] Marc Chagall, *Ma vie*, op cit, p. 81

[2] YL Obolenskaïa, *A l'école Zvantseva sous la direction de L. Bakst et M. Doboujinski*, 1906-1910. Manuscript kept in the manuscript section of the Trétiakov Gallery in Moscow, Russia

[3] *Ma vie*, op.cit., p. 108

[4] Bella Chagall, *Lumières allumées*, translated by Ida Chagall; illustrations from Marc Chagall, NRF Gallimard

[5] *Ma vie*, op.cit., p. 143

[6] André Breton, "Genèse et perspectives artistiques du surréalisme", in *Le Surréalisme et la peinture*, 1928-1965, Gallimard, Paris, 1979, p. 63

[7] *Ma vie*, op.cit., p. 154

[8] *Ma vie*, op.cit., p. 160

[9] Marc Chagall, Conference held at the university of Chicago by invitation of John Nef, Chicago, February 1958. Translation in French, typescript p. 18 quotation p. 17. Archives of the Musée National Message Biblique Marc Chagall, Nice. Published in English in John Nef, *Bridges of human understanding*. The University of Chicago, University Publishers, New York, 1964